THE LADIES OF CASTINE

THE LADIES
OF CASTINE

From the minutes of the Castine, Maine, Woman's Club

"The idea of clubs for women
was as distinctly American
as maple trees
and Ford cars."

by MIRIAM ANNE BOURNE

illustrations by LOUISE TABER BOURNE

ARBOR HOUSE New York

Book design by Kingsley Parker

Manufactured in the United States of America

10 9 8 7 6 5 4 3 2 1

Library of Congress Cataloging in Publication Data

Bourne, Miriam Anne.
 The ladies of Castine.
 1. Castine, Maine Woman's Club—History. 2. Women—
Maine—Castine—Societies and clubs. I. Castine, Maine
Woman's Club. II. Title. III. Title: Minutes of the
Castine, Maine Woman's Club. 1985.
HQ1906.C37B68 1985 305.4'06'074145 85-7500
ISBN 0-87795-729-0

For Virginia

CONTENTS

FOREWORD

FINDING THE MINUTES

December 7, 1918

"The Club voted to send the following recommendation to the Federation," read old minutes of the Castine (Maine) Woman's Club. The excerpt had been mailed to me one winter by my sister-in-law, who had just become president of the club.

"It's signed by your grandmother," Virginia wrote. "Apparently she was one of the first secretaries."

> The members of the Castine Woman's Club believe that the name "Woman's Reformatory" given to the Institution at Skowhegan for the purpose of helping their unfortunate sisters, does not voice the spirit of modern Sociology. . . .

I was amazed. It had never occurred to me that my stout, lavender-smelling grandmother had ever had any interest in modern sociology. It had never occurred to me that a women's club of that era, that a women's club of any era would *lobby* for a subject as sophisticated and subtle as the connotation of a name.

The next August while I was vacationing in Castine, Virginia and I headed for the town hall where the club minutes are stored.

"You're in for a treat," Virginia promised.

★　　★　　★

"Say, Laura," she asked the tax collector, "how about the key to the Woman's Club cupboard?"

"Sure, Ginny," came the agreeable reply. "Don't see any reason why not."

Laura directed us to a back room of Emerson Hall. Inside the locked cupboard were five black notebooks with red spines—minutes dating from 1913, when the Castine club was founded, to the 1970s. I clutched them to me and eagerly carried them home.

Settled on my front porch which overlooks the entrance to Castine's harbor, I opened the first notebook.

"The President urged the need of purchasing stamps, since the government is still in great need of funds," I read in my grandmother's familiar, bold handwriting. Turning the pages, other entries caught my eye.

". . . discussion of the question 'Extension of Suffrage to Women' . . . removal of old herring weirs . . . Castine boys in U.S. service . . . Ku Klux Klan . . . the Cost of Peace . . . Maine Baby Saving Society . . . the role of the earthworm in horticulture . . . humorous readings . . . opera (with victrola records)."

All day and into the night I read the minutes—fascinated because they were a microcosm of small-town, American concerns, moved because they revealed the complexity and diversity of women.

I was proud of my grandmother and her friends and neighbors for their work on local, state, national, and international

Club member Gertrude Lewis and her mother lived in this Greek Revival house on Main Street.

issues and touched by their efforts at self improvement. Impressed by the substance of the Ladies of Castine, I was charmed by their style.

"It was a beautiful day," they recorded. "The Club met in the spacious double parlors at the home of. . . . The meeting opened with a collect and singing of the Club song, 'The Pines of Maine.' The speaker was given a rising vote of thanks. On a yellow cloth on the tea table were deep russet, fall flowers and gleaming yellow candles."

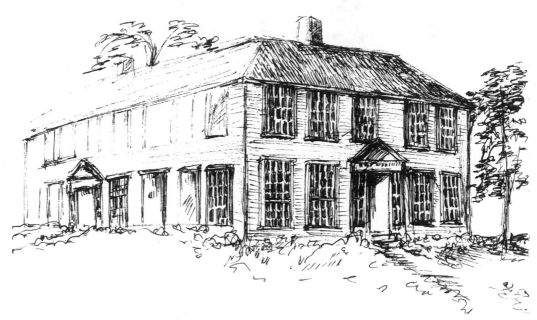

"Caddie" Walker grew up in this house, which her grandparents John and Phebe Perkins began building in 1763.

1 WHO THE LADIES WERE

Caroline Perkins Walker ("Caddie") was typical of the first members of the Woman's Club. Born in Castine in 1872, she had grown up in the eighteenth-century house of her great-grandparents, who had helped settle the town. Her parents, Melissa and Elisha, raised two daughters, as well as three sons who went to sea. Elisha was a farmer, not a sailor, not a ship builder and merchant, as his father and grandfather had been. As a little girl Caddie's favorite memory of the farm was the piglets.

School was a short walk away in the two schoolhouses on the town Common.

In her penmanship copy books were moral precepts.

It is never too late to mend.

Judge not at first sight.

McGuffey's *Readers* taught mercy, self-confidence, industry, pacifism, and kindness to animals.

Mary was up at six,
Up, up, Lucy, and go out to Mary!

I love my dear puss.
Her fur is so warm;
And if I don't hurt her,
She'll do me no harm.

Arithmetic problems used familiar objects.

A harness was sold for ¾ of ⅘ of what it cost. What was the loss percent?

Introduced in 1703, *Webster's Blue-Back Speller* had sold thirty million copies by the end of the nineteenth century. Imaginative sentences helped scholars memorize words.

Geography: *George Eliot's Old Grandmother Rode A Pig Home Yesterday.*

High school literature concentrated on British writers (Shakespeare, Milton, Byron). Grammar and public speaking were important; elocution was taught with gestures.

In geography Caddie memorized state capitals from a chant.

Maine—Augusta . . . on the Kennebec.
New Hampshire—Concord . . . on the Merrimack.

She learned that America was God's country.

Christian nations are more powerful and much more advanced in knowledge than any others.—*Warren's Common School Geography*

The United States are the freest, most enlightened, and powerful government on earth.—*Cruikshank's Primary Geography* [1]

At seventeen Caddie entered the Eastern State Normal School (for teacher training) at the top of Main Street. The only science courses taught—by men—were physiology and geology. The "normals" were young women and young men; when Elisha died, Melissa took in some of Caddie's schoolmates as boarders.

After graduation Caddie taught in the North Castine school and then on the island of Vinal Haven, where she met young Tufts graduate Will Walker. Will wanted to be "a big toad in a

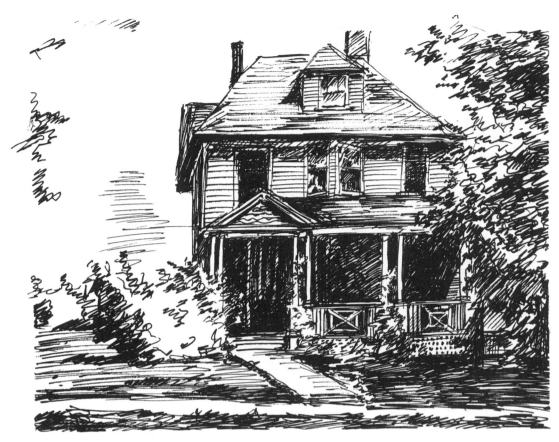

Caddie moved as a bride to this brand new house on Main Street just before the turn of the century.

little puddle." A registered pharmacist, he came to Castine to establish a drug store business and to manage the Acadian Hotel, which had been in his family for years.

When Will first came calling at the old house on Court Street, everyone believed he had his eye on Caddie's sister Mamie. But it was the "pleasingly plump" younger woman he was courting—"Prudie" he always called her. They were married at home in the parlor. Will took his bride to the fine, new, yellow house he had built on Main Street. A veranda graced the front; there were plate glass windows and plenty of bric-a-brac and potted palms.

3

The Walkers' first child was born at home in 1895; "my son Edmund" was his mother's pride all her life. Miriam Perkins (named for Caddie's grandmother) was not born until he was six; thirteen months later Caroline Ayer (Will's mother was an Ayer) surprised the couple.

"Babies come like a thief in the night," her mother once (before Freud) told her. In 1900 when Melissa died, Caddie's spinster sister Mamie moved in to help care for the Walker children; they adored her.

A hired girl came daytimes to clean and scrub. Upstairs she got the mop, broom and dustpan, and feather duster from the walk-in (with window), cedar-smelling linen closet and cleaned the five bedrooms. With a rag she polished the marble wash basin in the bathroom and the high-sided enamel tub with claw feet. Downstairs she ran a carpet sweeper over the living room rug, washed clothes on a washboard, and hung them outside to dry, no matter what the temperature. She visited with Noah Hooper, the iceman, when he hauled in on his broad shoulders a large chunk of ice for the icebox in the back hall.

Caddie was out in front, buying haddock from the fishman or ordering flour, baking powder, sugar, and molasses from Parker & Wescott's horse-drawn wagon. The delivery man took orders in the morning and brought the groceries to his customers before noon.

Caddie loved to cook. In her hefty wood stove in a large, cheery kitchen with separate pantry and china closet, she baked biscuits, blueberry pies, gingerbread, and baked beans. Fish chowder simmered on top of the stove. Will came home from the drug store at noon for a hearty dinner. Afterward in the music room he played the upright piano. "Gee, I Like Music with My Meals," he sang. "Which Switch Is the Switch, Miss, for Ipswich?" and "Sit Down. You're Rocking the Boat."

"Mr. Walker had a fine bass voice," a younger man reminisced. "I can even remember what he sang in church: 'Open the Gates of the Temple' and 'Hold, Thou, My Hand in Thine.'"

Afternoons Caddie socialized. "Genial and social by nature, she attracted to her a wide circle of friends." "Full of fun . . . a

great raconteur and bit of a gossip . . . a very bright woman," a younger friend recalled years later. Sunday mornings when the Congregational, Unitarian, and Methodist church bells tolled in sequence, Caddie marched her family down to the "Congo" church. But she belonged to the Alliance, the Unitarian women's group. "While its work is necessarily of a religious character, it is also interested in charity and has become a social asset to the town," says the *History of Castine* (1923 edition, p. 392).

"They made a *big* exception when they let Caddie Walker into the Alliance. That's where her friends were." (She also had friends in the Congregational "Circle.")

Caddie played bridge, too, joined a reading club and a needlework guild. One big project was a crocheted, popcorn stitch bedspread. In 1913, when neighbor Lizabeth Hooke suggested a Castine Woman's Club, forty-one-year-old Caddie Walker was ready and willing to join.

The founding members of the club ranged in age from the thirties to the early sixties; most—like Caddie—were in their forties. Many of the women were born in Castine; an equal number came from nearby towns or as far away as Boston. They were the mothers of from one to three children, seldom more. There were "no flies" on the ladies. Consider the following.

Club member Hattie Philbrook invited high school students to her home on Friday afternoons for music lessons. (Her husband, Edward, a homeopathic doctor, was a music lover, too.)

"The principal sent me along to the Philbrooks' to maintain discipline," chuckled a former high school teacher. "It was the last place they wanted to be then. She was good to do it; and as I remember, she did teach them some good music. But you see, the students had learned parodies to all those songs. . . ."

Lilla Patterson sang and played piano and banjo. A graduate of Wellesley, she had taught Latin and Greek in various high schools before her marriage to a Congregational minister. There was less emphasis on theology at this time, claims historian Richard Lingeman. More attention was paid to activities than sermons, which were inclined to be "tepid moralizings." George Patterson was an exception.

"He was the *most* erudite man," remembers an admirer.

Lilla was active in the Young People's Society of Christian Endeavor and a fine public speaker, who lectured throughout New England. "As the Congregational minister's wife," she wrote the Wellesley alumnae office, "I was supposed to be always ready to give time to the poor of a place, to parish work, missionary meetings, conventions, Christian Endeavor, Sunday School, etc."

Another charter member, Lillian Carpenter, was "a singer of great merit, while Mr. Carpenter (owner of the Line and Twine

factory) enjoyed dramatics; between them they could easily manage an evening's entertainment" *(History of Castine,* 1923, p. 414). Lillian was "friendly and nice; she organized the Unitarian choir and paid the singers. She had a strong voice; I remember her singing 'Mine Eyes Have Seen the Glory,'" an elderly man says with pleasure. Lillian was filling an out-of-town singing engagement the night the Line and Twine factory was struck by lightning and burned to the ground.

Caroline Benjamin taught Sunday School at the Congregational church. "She was a nice woman," a childhood friend of her son Philip reports. "When we were in grammar school, the teachers wanted us kids read to. Philip's mother would come next door to our house evenings and read *Treasure Island* aloud. The whole family'd gather round—my mother and father, my grandmother and grandfather, my brother Charles. I remember it well as can be."

One-third of the original members of the Woman's Club were single, several of them teachers at the "model school" at the Normal School or at the "common" grammar and high schools. Margaret Webster was a nurse who had worked with medical missionary Dr. Grenfel in Laborador before marrying a doctor.

Middle-aged Miss Amy Witherle, a Wellesley graduate, "was treasurer of the Unitarian church, and kept some of their funds in the house," Lilla Patterson's son recalls. "When someone she knew needed money to meet an emergency on Sundays when the stores were closed, she would open up a massive sea chest in the hall, full of old records of the Witherle ships, to get the money."

The Castine ladies were proud of their maritime past. They were proud and fond of their little town. An earlier woman, Mrs. Evans, had expressed it well in the 1896 edition of the *History of Castine* (p. 66).

> And yet there's not on earth, I ween
> A fairer spot than old Castine.
> O would that there my home might be,
> Down by the moaning sea.

2 THEIR TOWN

Its History

When Caddie Walker's great-grandparents John and Phoebe Perkins helped settle Majabigwaduce (as Castine was called) in the late 1760s, it had already been fought over for a century and a half by French, Dutch, and English traders and missionaries. From about 1667 to 1701 a French nobleman, Baron Jean Vincent de St. Castin, had maintained a virtual fiefdom there. He married the daughter of Madockawando, chief of the Tarratine Indians. The Woman's Club ladies read about her in a poem of Longfellow's, "The Baron Castin of St. Castin."

> A form of beauty undefined,
> A loveliness without a name.

They read about the baron in Whittier's "Mogg Megone."

> One whose bearded cheek
> And white and wrinkled brow bespeak
> A wanderer from the shores of France.

Majabigwaduce was quiet and apparently uninhabited for the next sixty years, until English settlers arrived after the 1763 peace treaty with France, which determined the boundaries of the North American colonies.

Some years later Britain's colonists rebelled against their Mother Country. Seven or eight royal ships sailed into the harbor of the fledgling town one summer day in 1779 and landed

seven hundred men. The red coats commanded the citizens to help them build a fort (Fort George) at the top of the hill and withstood a heroic but inept siege by the Penobscot Expedition, a rag-tag flotilla carrying Continental troops from Boston, including artillery commander Paul Revere.

In the early 1800s the town (incorporated as Castine in 1796) thrived, with grist mills, tannery, custom house and county courts, seven warehouses, rope walk, and sail loft. Caddie Walker's grandfather and great-grandfather sent the ships they built to Liverpool and the West Indies. Castine protested in vain to President James Madison against war in 1812; and the enemy occupied the town again from 1814 to 1815.

Amy Witherle's and her cousin Anna's family prospered in the shipping business from 1830 to 1850. Removal to Ellsworth of the courts in 1838 was an economic blow to the town; the Civil War and fishing competition from elsewhere brought a decline. But by 1875 when the first edition of the *History of Castine* was published, Castine "still throbbed with the spirit of enterprise."

"The women of Castine's past," says the 1923 edition (p. 347),

> We can count them by the scores. If the men have struggled to earn the daily bread, their wives surely baked and brewed, swept and garnished, brought up their children in the straight and narrow way, and between times, by their hospitality, their native wit and their integrity have gained for the town its fair name.

Natural Beauty

When the clock in the tower of the Congregational church on upper Main Street strikes the hour, its pleasant sound resonates all over town. The daring workmen who periodically climb up to paint the steeple above the clock's four faces can see the entire length (three miles) and width (one and a half miles) of the Castine peninsula and "off the Neck" to North Castine. Bound on

the west by the broad Penobscot River and the east by the Bagaduce, the rocky southern tip thrusts into vast Penobscot Bay, which sparkles like sapphires and diamonds every season of the year. To the north the British Canal, built by the enemy when it occupied the town in 1779, makes Castine an island at high tide.

In 1913 when the Woman's Club was founded, the ladies of Castine admired the play of light and shadow on white houses, the deep blues of water and sky, the dark greens of pine tree, hackmatack, and fir, June fields of pink and blue lupin.

The islands in the harbor and bay were choked with towering evergreens. At the Head, wind-ravaged trees clung tenaciously to weather-beaten cliffs, defying gravity. Herring gulls and osprey circled and mewed overhead; rows of black cormorants skimmed the waves. Calm in the morning—calm enough to disclose the shiny head of a seal—the Bay was swept afternoons by a stiff southwest breeze that sent breakers crashing on the rocky Bagaduce shore. The bell buoy marking the harbor entrance clanged, and the ladies sniffed the fresh salt air.

Business

From their houses on upper Main Street ("Quality Avenue"), Pleasant Street, and Court Street, they walked under elm trees on new, concrete sidewalks down lower Main Street to the post office (and customs house). Across the street was Warren Hooper's livery stable.

Lower Main Street plunged down to the water, past the Pentagoet Hotel, Noah Hooper's funeral parlor, Patterson's grocery store and meat market on one side, the Castine House, Dot Grindle's millinery shop, and McCluskey's clothing store on the other.

On the corner Will Walker's drug store carried Sweet's White Pine Compound, Mavis Talcum, and Feenmint gum, as well as prescription drugs. Here the ladies could buy the *Ladies' Home Journal, Good Housekeeping, Saturday Evening Post,* and *Collier's.* Walker's candy case served up nougatines, peanut brittle, turkish

11

paste, nonpareils, butterscotch, caramels, and chocolate-covered almonds.

On east Water Street (at right angles to Main Street) Al Clark sold hardware and rented space to Messrs. Seybt and Brown for moving pictures. (In 1915 the Folly Theatre was built across the street.) Parker & Wescott carried "Fine Family Groceries." At the telephone office "Central" reigned. (Telephone poles had been erected in 1893; by 1900 there were ten subscribers. Electric lights were installed in 1915.)

"We could always ask the operator where Mother and Father were visiting," Caddie and Will Walker's daughters remembered. "She could tell you that Anna Witherle wasn't home; she had just gone in the drugstore," a friend agrees.

First selectman Willis Ricker's store on west Water Street sold "pianos, organs, player pianos, graphonolas, and records."

"Ricker operated behind a table displaying newspapers," an old-timer remembers. "If he was in an adjoining room tuning a piano, he wouldn't come out until he had achieved a 'plunck' which satisfied his desire for perfection." On Ricker's second floor Dr. Payson filled teeth.

Next door was Wescott's Shoe Store, "which carried durable footware appropriate and serviceable for rural use. For more dressy and fashionable shoes people waited until a representative of Dinsmore's Shoe Store in Belfast came for a week each year; his shoes were displayed in the lobby of the Castine House."

Brown's hardware store was also on Water Street. "Walter Brown was easily irritated. A favorite prank was to send some innocent youth in to ask him if he carried left-handed monkey wrenches. The response was likely to be unfit to print." Across the street were Wardwell's Sanitary Market, Mr. Seybt's photography shop, and sturdy, dependable Ethel Noyes's notions.

On Sea Street parallel to and just below Water Street were Eaton's boatyard, an ice warehouse, where sawdust and seaweed-covered ice was loaded onto schooners, and Dennett's wharf with boats for hire, sailing loft, and bowling alley. A coal wharf was on Sea Street and Will Hooper's livery stable, rival to his brother Warren's. At Chamberlain's ice cream parlor "one could sit in a cool room at a glass-topped table, enjoying a dish

or cone of ice cream—homemade, rich, and creamy."

Twice a day the tide rose and fell 9.7 (mean) feet. Fastened to the long pilings of the wharves were dozens of red starfish. Fishing boats, an occasional naval vessel, and sailing yachts passed in and out of the deep harbor, where "all the navies of the world could float with ease."

But what attracted the ladies and everyone else in town was the steamboat wharf, where the Maine Central Railroad's *Pemaquid* and *Sieurs de Monts,* the Eastern Steamship Company's *City of Bangor* and the *Silver Star* and *Golden Rod* arrived regularly from Rockland and Bangor.

"The skippers took pride in how skillfully they could bring the boats into the wharf and impress their audience," a man remembers. "A frequent diversion for the onlookers was to watch some daring youth dive from the top of the coal wharf structure, a 75 or 100 foot dive."

Katharine Butler Hathaway memorialized the *Golden Rod* in *The Little Locksmith*.

> The Rod was a dowdy, ridiculous old lady, creaking terribly in every joint, yet she always had her gloves on and her bonnet at a jaunty angle as she went careening across the Bay, bouncing ridiculously and showing her petticoats, or else primly gliding in an air of intense propriety and self-satisfaction according to the wind.[1]

Summer Folk

Summers the steamers brought school teachers to the boarding houses in Castine and wealthier folk to the Acadian and other hotels—people from Boston, New York, Philadelphia, and Washington, arriving for the summer with trunks, maids, and tutors for their children.

> The location [of the Acadian] is perhaps finer than any other hotel in the state. You will notice it faces the steamer landing and rises by terraces to quite a height. It is roofed under

The Acadian Hotel

the Spanish order, while the grand porch, fifteen feet wide and nearly two hundred feet long, extends along the entire front, affording a view of the Bay entire, the broad Penobscot River, islands, and distant timbered ridges.—Acadian brochure

The scene by moonlight on the glistening waters is particularly pleasing, as the lighted steamers and sailing crafts glide about or lie at anchor. The beautiful walks and drives in the pine and birch forests, and the social tourists who enjoy duplicate whist and progressive euchre as we do, have held us a little longer than intended.—letter from G. C. Loveland to F. E. Stiteley, IL

Rates: $3.00 per day and upward. In the basement is located a large Billiard Hall where guests who desire that sort of entertainment can amuse themselves.—Acadian brochure

I have vivid memories of walking along Perkins Street about 7:00 in the evening, when Castine natives had finished their suppers, but the urbane guests at the Hotel were just starting to dine, and being impressed by the gleaming white tablecloths, and the shining china and silver.—Donald Patterson

Traveling stock companies came on the steamers, too. They paraded up Main Street while someone beat a drum, local boys handed out flyers in exchange for tickets, and a boy actor with a beautiful soprano voice sang, "Pony Boy, Pony Boy, Won't You Be My Pony Boy?"

But by 1913 Henry Ford had introduced the moving assembly line and his automobiles had invaded Castine. In another decade summer cottages would supplant the summer hotel. Already speed limits had been posted in Castine and autos forbidden on certain streets. On Perkins Street, which stretched toward the Head, summer cottages had been springing up since 1876.

"How does business promise at Castine for another year? Well, I will tell you that Castine is just booming," remarked

Dr. Frederick Pierce, who lived with his family in this "summer cottage," lectured to the ladies in 1929 on "The Evolution of the Brain." 17

Frank P. Wood on Monday in answer to a query from a *Commercial* reporter. "Why an investment along the Maine coast nowadays is just as good as being in touch with the United States mint. There is no substitute for the Pine Tree State, and the city people have to come here."—Old newspaper clipping

The Woman's Club ladies welcomed the "rusticators." Dorothy Blake was asked to speak on "My Trip Through the Panama Canal"; in time, some of the summer regulars were invited to join the club. The ladies' husbands joined the summer men in building a nine-hole golf course. There were already six tennis courts in town, one on the Acadian lawn, one at Lillian Carpenter's house.

On the town warrant at the 1913 town meeting was the question: Whether to continue the sewer on Perkins Street to Madockawando Road "in order that the owners of cottages now built and to be built may not be compelled to use unsanitary sess-pools." The town voted Yes.

Amusement

The automobile made it easier (once the machinery and roads were good enough) to drive to the Back Shore (in linen duster, large hat and veil) to see the sunset and after-glow. Down Windmill Hill traveled the ladies, across the British Canal, past Dunk's meadow, and around the "Ten Mile Square" to admire the views, or off the Neck and up Hardscrabble Hill to the cities of Ellsworth and Bangor. Wherever you went was up and down.

The ladies, as much as the summer people, enjoyed rides in Warren or Will Hooper's fringed buckboards on carriage trails through Witherle Park, the lovely woods preserved by Amy Witherle's father. Yellow and orange Indian paint brush grew in the clearings, and the ladies snipped evergreen tips to make sweet-smelling fir pillows.

Island picnics were popular. The ladies brought hampers of

good food, and the men steamed clams in seaweed and drift-wood fires. In a few years teen-aged daughters and some of the younger Woman's Club members would wear knickers and scandalous bathing suits that revealed their legs. But in 1913 middle-aged matrons still dressed in the long skirts and long-sleeved, high-buttoned shirtwaists they had worn as schoolgirls. Skirts were a trifle shorter, but it's hard to know why a 1913 clergyman complained that "never in history were the modes so abhorrently indecent as they are today."[2]

Decorously lifting their skirts to ankle length, they (like their children) explored the barnacle-encrusted cliffs which gulls had littered with dropped clam and crab shells, and where sometimes an ancient fossil could be found. They inspected the low tide beaches where colonies of blue-black mussels, dog whelk, snails, and sea urchins clung to rocks, microscopic, moving sea creatures inhabited tidal pools, and seaweed snapped if you stepped on it. Sand-dollars and scallop shells might be carried home, and various small rocks which looked dull gray to the careless eye, but when examined closely were the rich browns, pepper and salt, green, white, purple, amber, and black of rocks in water. One with a white ring around it was a lucky stone.

Children ran along the beach, flapping devil's apron strings—a long, firm, golden seaweed that flared at one end. The ladies picked sea lavender to take home and wild blackberries and blueberries.

Warm weather evenings the ladies joined the other townsfolk in climbing up to Fort George, a rectangular field surrounded by four grassy ramparts. Here town baseball games were played, fondly described by Castine's most renowned citizen, Noah Brooks, in his book for boys, *The Fairport Nine.* Born in Castine in 1830, Noah Brooks had become a journalist in cities from Boston to California, was a friend of Bret Harte and Mark Twain, and served as President Lincoln's assistant secretary.

Memorial (Decoration) Day the whole town strolled along Court Street, past the town hall (built in 1901) to the typically New England Common. Surrounding the Common were several old houses and the handsome Unitarian church, built from an earlier meeting house in 1831–32. Of equal interest to the ladies were the mid-nineteenth-century Abbott (grammar) School, the Adams (high) School and the brand new Witherle Memorial Library.

A granite Civil War soldier stood on the Common in honor of the hundred or so Castine men who had served. In 1913 ten or twelve veterans of the Grand Army of the Republic marched in the Memorial Day parade. So did veterans of the more recent Spanish-American War. After the ceremony the ladies and their families walked up to the nearby cemetery, one of the loveliest spots in town, to decorate graves with geraniums.

Fourth of July fireworks were launched from a barge in the harbor: ". . . beautiful examples of Parachutes, Floating Lights, Balloons, Serpents, Dragon Tails, Snakes, Silver Streamers, Gold Rains, Electric Suns, and other devices," claims a yellowed announcement. Average Fourth of July temperature was in the mid-sixties. (Although freezing temperatures were common in winter, twenty degrees was average for January.)

In winter the children sledded on Pleasant Street (to the consternation of several of the Woman's Club ladies) and skated in the flooded moat around Fort George. Young people and their fathers trudged through the woods on snowshoes. The ladies went calling instead.

"Separated and almost isolated as they are by the surrounding

water," wrote Castine's historian George Wheeler, "the citizens of this place are, and have always been obliged to find their sources of amusement at home." *(History of Castine,* 1923, p. 74).

The Husbands

Will Walker was into everything. For years he was moderator of the town meeting; he helped found the historical society, joined George Patterson's Shakespeare Club, served as library trustee, president of the Castine General Hospital, juryman, and state senator. He bought stock in a fishing weir, with a group of other men proposed a Castine shoe factory, had something to do with the water company. Will umpired the baseball games at the fort, was a founding member of the Castine Golf Club. When his girls were twelve and thirteen and Edmund was at Bowdoin College, he packed up the family and moved to Cuba's Isle of Pines for a short-lived, futile attempt at hotel keeping there. Every May he moved the family out of the Main Street house down to the Acadian for the summer.

"Will Walker was very economical; he didn't waste a dollar," an elderly man recalls. "Here's a rhyme they made up about him for 'The District School.' (That was an amateur theatrical, sponsored by the Woman's Club. We had some real good local talent. Kate Davenport—she was the librarian—was quite a comedienne.)

W is for Walker.
He knows a thing or two.
He'll take two feathers and a bone
And make a chicken stew.
Will had some,
The guests had some,
The help had some besides.
What they did not eat that night
They had next morning fried.

The Castine men loved to tease each other and the ladies. A group of friends who called themselves "The Country Cousins" sang and dined and had picnics together. Gen Hooper's friends still chuckle because her husband Will always wanted some of "Wife's cake."

Lillian Carpenter's husband, Edward, made up and had printed a comical "Menu."

Fruit

Pears—impossible to find a pair to beat Sisters Hooper and Jones
Peaches—all the ladies present are peaches, especially Maria
Plum(p)s—served *à la* Sisters Walker and Hooke style

Soup

Any Old Kind. The poor husbands are in it on Bridge Matinee Days

Game

Old Maid (none present, of course. The idea!)

Meats

Lamb—as gentle and as tender as the Perkins Sisters

Dessert

Custard, minus the cusses (Gentlemen will please take notice)
I-Scream (for supper on bridge days, but it is no use)

When his Line and Twine factory burned in 1913, Edward was at his Harvard reunion. As soon as he could, he rebuilt. The company had a "very valuable right in an invention which keeps the lines from becoming snarled and twisted," an admirer recalls. They were "long troll lines—short baited with clams—caught beautiful cod and haddock."

"It was interesting to watch the 'runners' weaving line in the ropewalk," says another.

A hot local issue in 1896 had been whether or not to rent hydrants from the water company. Caroline Benjamin's husband bought the business in 1907. "Since that time he has given devoted service to the Water Works and by many improvements kept an up-to-date plant," wrote an admirer (*History of Castine, 1923, p. 368*). "He was a good water man," claimed another.

Although the town was tucked into the northeast corner of the United States, the town fathers kept informed of county, state, national, and international events through newspapers and correspondence. Castine men had always served in the Maine state legislature and before statehood in the Massachusetts General Court; Will Walker's cousin Charles Littlefield was in Congress in 1913. That was the year the amendment passed which provided for direct election of United States senators. Cocky about their early presidential primary, Castiners like other Mainers claimed before each election: "As Maine goes, so goes the nation."

In 1898 news of fighting in Cuba and the Philippines had been phoned in regularly to one of the few telephones in town—at the drug store. Castine knew when Admiral Peary "discovered" the North Pole in 1909, when the *Titanic* sank in 1912.

The Woman's Club husbands admired progressive Republican president Teddy Roosevelt. George Patterson wrote a poem about him.

Our Strong Man

Outspoken, plain of speech,
 Frank, forceful, bold,
Ambitious? Ay; yet not
 Himself to serve.
His catholic aim would guard
 All rights, yet raise
The man whose lot is hard
 To larger days,
Where toil may find its rest
 And work its image,
Til each fulfills his best
 And serves his age. . . .

The 1912 presidential election severely divided the GOP electorate. Seventy-one Castine men voted for Bull Moose candidate Roosevelt and thirty-seven for Republican Taft. Ninety-six voted for Democrat Wilson, none for Socialist Debs. President Woodrow Wilson took office on March 4, 1913, just one month before Mrs. Hooke and other ladies started the Castine Woman's Club.

3 PEDESTAL TO POLLS (1913–1919)

A former president, Grover Cleveland, had advised women not to join clubs in the April 1905 *Ladies' Home Journal*— except those with "purposes of charity, religious enterprise, or intellectual improvement. . . . Her best and safest club is her home."[1] Cleveland was reflecting the prevailing attitude toward middle-class women. Their primary responsibility was as wives and mothers; it was the highest calling.

Race Suicide Laid to Girls' Colleges

Separate colleges for women in the United States should be abolished and co-education substituted, according to Prof. Roswell Johnson and Bertha J. Stutzmann of the University of Pittsburgh. This conclusion is based on the charge that women's colleges contribute largely to race suicide among the best elements of the American population.

In support of this contention the records of Wellesley College have been analyzed. . . . The investigation found that twenty years after graduation fewer than one half of the girls have married. These have borne only one and one-half children each . . . the Wellesley girls contribute less than one child each to the race; that is, they do not even reproduce their own number. . . . The colleges are blamed for failure to give girls an opportunity to meet young men and for failure to make them desirous or competent to be wives and mothers.—*Bangor Daily News* (May 27, 1915)

A newspaper reported of a lecture by Hon. Carl Schurz at Brooklyn, New York, in the early 1900s:

He regarded women as the soul of the family home, regarded the mother as the being who holds the leading strings in her hands, and who had the highest, most exalted duties to fulfill. . . . While the father works, the mother teaches. She opens our eyes to see, and our minds to understand. The germs of good or evil she first plants into our souls. The home . . . is the first school, and the mother its genius.

There was a certain danger for this paragon on a pedestal—"the emptiness of her daily life," admitted Schurz. He recommended "as a pursuit music, or painting."

Another lecturer and writer, Charlotte Perkins Gilman, deplored this homebound attitude. "By what art, what charm, what miracle has the twentieth century preserved *alive* the prehistoric squaw?"[2] she cried.

A squaw at least worked along side her husband, as earlier American wives had done. The idea of full-time mother (rather than economic helpmate) came as husbands worked increasingly away from home. Factories made some clothes and tinned food was available (about 1880). Servants were plentiful at low wages, so many middle-class women had leisure time.

Actually, most American women were never full-time mothers. Churchwomen in Elizabethtown, New Jersey, organized the Female Prayer Book and Tract Society in 1814; in 1827 a Ladies' Circle of Industry was organized in Bellows Falls, Vermont. At mid-century twenty-one Boston women and one man paid Louisa May Alcott's mother, Abby, thirty dollars a month to be a "Missionary to the Poor." Most impressive was the Sanitary Commission, which during the Civil War raised $30 million for food, uniforms, and medical supplies for Union soldiers.

It was the Gilded Age middle-class that "in the main sustained the churches, . . . kept alive foreign and domestic missions, supplied the sinews for the anti-saloon movement, backed the WCTU."[3] And as contemporary historians are demonstrating, in cities and towns most of those workers were women.

When I read in the paper and heard in the Club that a dozen women of great wealth were standing along Broadway handing bills and encouragement to the girl shirtwaist strikers of last winter, I was not a bit surprised. It is just what you might have expected. Nowadays I can hardly go to a reception or a ball without being buttonholed by somebody and led into a corner to be told all about some wonderful new reform.—from the diary of a Gilded Age plutocrat.[4]

American women "have societies and clubs," wrote an Englishman to Rudyard Kipling in 1891, "where all the guests are girls. . . . They can take care of themselves; they are superbly independent."[5]

He was right. The roster of national women's groups organized at the time is extraordinary.

> 1882—Association of Collegiate Alumnae (later AAUW)
> 1883—Women's Relief Corps (GAR Auxiliary)
> 1890—General Federation of Women's Clubs
> —National American Woman Suffrage Association (merged from two earlier groups; became League of Women Voters)
> —Daughters of the American Revolution
> 1891—National Pan Hellenic Association
> 1894—United Daughters of the Confederacy
> 1896—National Association of Colored Women
> 1912—Hadassah
> 1913—Garden Club of America

The General Federation of Women's Clubs (GFWC) began when a New York club called Sorosis celebrated its twenty-first birthday by inviting other clubs to a joint meeting. (Jane Cunningham Croly, a journalist, had founded Sorosis in protest against the New York Press Club's exclusion of women from its dinner for Charles Dickens.) Sixty-one clubs accepted Sorosis's invitation, formed the Federation, and subsequently held conventions every other year. Cultural at first, the clubs soon added

29

social welfare, national and international affairs to their concerns. In 1904 a U.S. congressman reacted to the phenomenon.

> This is fast becoming a government of the women, for the women's clubs, and by the women's clubs. Strange that the men do the voting and elect us to these positions, while the women assume the duty of telling us afterward what they want us to do. . . . Why, if the women of the country should suddenly decide that they wanted the tariff revised, or a rate bill passed, or the coal mines nationalized, we should have it before the men would wake up to know what had happened. The petitions from the women's clubs would do the work. . . . And they have never been known to quit.[6]

At its first Biennial in 1892, two hundred clubs with twenty thousand members had joined the General Federation of Women's Clubs. By 1900 there were one hundred and fifty thousand; before the end of the Progressive era, one million. Teddy Roosevelt appointed Federation President Sarah Decker the only woman delegate to the Governors' Conference on the Conservation of National Resources in 1908. Federation support helped create Rocky Mountain National Park in 1915 and the National Park Service. The Secretary of State made Federation President Anna Pennypacker a delegate to the Pan-American Scientific Congress in 1916; five years later she was one of four women appointed by Warren Harding to the Advisory Committee for the International Conference on the Limitation of Armaments.

The *New York Times* expressed doubts about club women in a 1917 editorial. "This country is rich in women who have much time to themselves and have to kill it—some in . . . listening to papers on every subject under heaven at women's clubs."[7]

The ladies had their own opinions. "You see we are no longer ashamed of our intelligence on the affairs of nations," said a Federation president. "A number of us read the newspapers. We used to build the fires with them and esteem them for the pantry shelves."[8]

"Club women are like Kansas corn," said suffragist Carrie Chapman Catt. "You can see and hear them grow."⁹

"The idea of clubs for women," a Maine Federation speaker once told the Castine Woman's Club, "was as distinctly American as maple trees and Ford cars."

The Club Is Founded

Away back in the winter of 1913 there were many conferences during early morning calls, which would later result in a determination on Mrs. Hooke's part to realize club life for the women of Castine.

On February 2nd (Ground Hog Day) Mrs. Hooke took one of her early morning constitutionals, accompanied as usual by her dog "Moses." About 9 A.M. she rang Mrs. Devereux's bell.

Now Mrs. Devereux had been moved to clean house a bit that particular morning, but with a smudge across her nose, she rushed to welcome Mrs. Hooke and Moses. . . . But Moses became early and unduly restless and uneasy and, the limit of his endurance reached, he arose and *did things!*

Mrs. Hooke proceeded to cross the street to talk Club and Club and more Club with Mrs. Perkins (who had been a member of the Alhambra, California, Woman's Club). And then was created in Mrs. Hooke's soul the firm purpose to take her desire . . . to a more experienced mind and hands —namely Mrs. Bartlett's—and Mrs. Bartlett lived a few minutes walk down Pleasant Street.

Meanwhile, Mrs. Devereux proceeded to wash the table leg and go back to her pots and pans—never dreaming what great question was being decided in her neighborhood— Mary D. Devereux, first club historian, February 2, 1936.

Lizabeth Maxcy Hooke was fifty-two in 1913, founder of a reading club as well as the Woman's Club. She was "very much for suffrage . . . serious . . . a leader," folks remembered. "Mrs. Hooke was a gracious hostess; they always did things nicely." "She was a little haughty," friends chuckled. "It's just a Ford," she had said of her automobile, "but a very nice Ford."

Mary Dunbar Devereux was ten years younger than her friend Lizabeth, had been a teacher, was interested in history, belonged to the Maine Writers and Research Club and the Unitarian Alliance. While living in New York City, Mary wrote about and raised funds for the Home for Aged Women of the Sea. Her husband, Captain Charles, "could command a whole ship," neighbors teased, "but not Mame." "She didn't give up the floor easily," a club woman remembered.

> On March 26 (1913) at 11 A.M., Mrs. Boyd Bartlett was busily beating up a loaf of angel cake. The side door opened softly and in walked Lizabeth Hooke.
>
> "Lu," she said, "I must have a talk with you. I have a serious project to suggest. I want a woman's club started here and I need your help."
>
> As I remember, my answer was, "Oh, forget it, Lizabeth. What do we want a woman's club for in this small town, where we have an Alliance, a Book and Thimble Club, a fine Shakespeare Club, the remnant of a Historical Society, and a Village Improvement Association?"
>
> However, Mrs. Hooke put forth several weighty reasons for the club, and so finally, the Castine Woman's Club was conceived. [Continued from Club history.]

"Everybody loved her," said a younger woman of Louise Wheeler Bartlett, who was forty-nine when she helped found the Woman's Club. "Relaxed . . . easy . . . comfortable and undemanding . . . fun . . . door open to everyone." Brought up in a household of readers, she had a book and crossword puzzle in every room. Like Mame Devereux, Lu was a member of the Maine Writers and Research Club, helped her literary, physician father with the new edition of his *History of Castine* (1928). Active in the Unitarian church and presiding officer of the Suffrage

League, Lu had been president of a woman's club in Chelsea, Massachusetts. "If she had an opinion about something, it was a strong one," says a daughter-in-law.

April 5, 1913–
About twenty-five (prospective) members of the "Castine Woman's Club" met with Mrs. W. F. Hooke this afternoon with purpose to organize and make arrangements for future work. Mrs. Boyd Bartlett was chosen temporary chairman and Mrs. C. W. Devereux secretary for this meeting. The committee on by-laws reported and the following articles were adopted.

Article 2. Object: The object of this club shall be civic improvement and literary and social culture.
Dues: $1.50 a year.
Meetings: 3rd Sat in Oct.
 1st Sat. of following 7 months at 2:30 P.M.
Minimum Age: 18 years.
Woman's Manual authority for conduct of meetings.

There are at present a great many women perfectly well fitted, so far as intelligence and interest go, to share in the deliberations of any assembly, but who, through lack of knowing the technique of parliamentary law, are kept from taking active part in the many meetings that they constantly attend. Eager as listeners, wishing they dared speak, reproaching themselves afterward for not speaking, they need only the confidence which comes from "knowing how," in order to become active, vital forces.—Harriette R. Shattuck, *The Woman's Manual of Parliamentary Law,* 6th edition (Boston, 1896)

The following officers were elected: Miss Mary Richardson, Pres. . . . Departments were established: Program, Household Arts (refreshments), Study Class (history, biography, art, literature, current events), Civics.

Club president Mary Richardson lived in this Federalist house on Main Street.

A teacher at the Eastern State Normal School, President Mary Richardson reorganized its circulating and reference library, classified the books by the Dewey Decimal System. Later she became the librarian of a normal school in New York.

May 3, 1913–
The first annual meeting was held today at the home of the President. 29 members were present. The meeting was opened by the members reading together "Collect for Club Women." Mrs. Carpenter sang the State Federation Song, "The Pines of Maine."

> O pines of Maine, dear pines of Maine,
> With thy proud heads uplifted high,
> Telling the tales of days long dead
> To all the woods, and streams, and sky.
> Thou art high born, O pines of Maine!
> All nature helped to give thee birth.
> Thy father was the sun and wind,
> Thy mother, the dark soil of earth.
> —Elizabeth Powers Merrill of Skowhegan

Collect for Club Women

Keep us, O God, from pettiness; let us be
large in thought, in word, in deed.
Let us be done with fault-finding, and
leave off self-seeking.
May we put away all pretense and meet
each other face to face without self-
pity and without prejudice.
May we never be hasty in judgment and
always generous.
Teach us to put into action our better
impulses, straightforward and unafraid.
Let us take time for all things; make us to
grow calm, serene, gentle.
Grant that we may realize it is the little
things that create differences; that in
the big things of life we are as one.

And may we strive to touch and to know
the great common heart of us all; and,
O Lord God, let us not forget to be kind.—Mary Stuart of Colorado

Mary was known for her epigrams. "Among her best is: 'One of the great fallacies of the day is the thought that women can not work together harmoniously.'"[10]

May 2, 1914–
Second Annual Meeting . . . voted that the club extend a rising vote of thanks to the member whose interest in the community and whose fore-thought moved her to organize this club, and whose zeal and enthusiasm not only have never flagged, but have inspired others to give hearty support and assistance to the organization, and to whose efforts we are greatly indebted for the success of the undertaking and the results so far attained—Mrs. W. F. Hooke.

May 1, 1915–
Third Annual Meeting. For the first time the club voted by printed ballot.

December 4, 1915–
The President then announced that the meeting would be conducted strictly according to Parliamentary Law in order to see how we like that method.

May 17, 1916–
An executive board meeting was held at the President's house in the midst of a raging tempest.

The object of this club shall be . . .
"Civic Improvement"

May 3, 1913–
Mrs. Hooke reported for the Civics Department calling attention to the following needs: abolishment of the common drink-

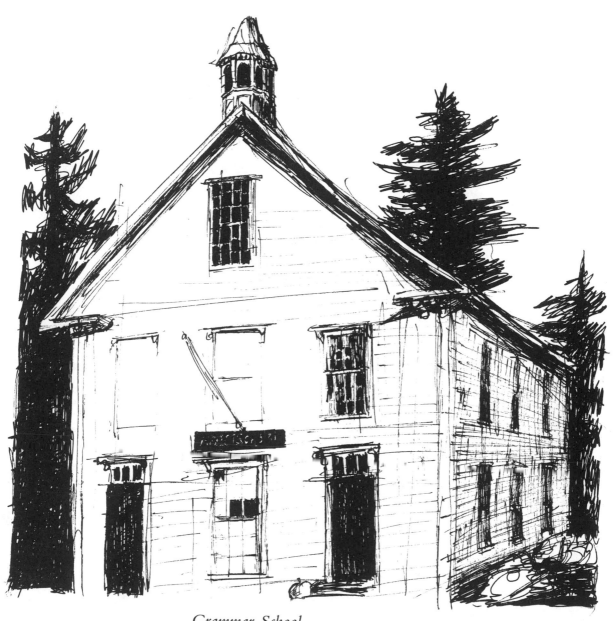

Grammar School

ing cup in school buildings [replacement by a "sanitary bubbler"], provision of receivers for paper and rubbish at street corners . . . more children's books and magazines of all kinds in the library.

October 18, 1913–
Mrs. Hooke said that she had seen Mr. Clark, Superintendent of School, in regard to the drinking fountains for schools. . . . It was found best to use barrels (for waste); these were furnished by grocers. The carting was done by Mr. W. H. Hooper and painting by Mr. Wheeler. It was voted to pay the bill for paint . . . conditions in library improved, but books and magazines are still needed.

March 7, 1914–
The idea of having a woman on the School Committee was presented. There was some discussion, but no definite action was taken.

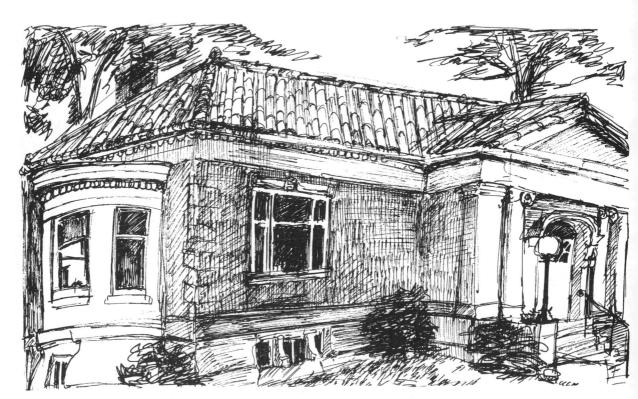

Witherle Memorial Library

1914 Town Report.
"This year three men and two women were chosen members of the library committee."

May 2, 1914–
The following recommendations were made by the Civics Committee for spending money earned at the suffragette Town Meeting: for the library—to be used either for statuary or for shrubbery or for lawn . . . voted that the Club ask to have the town watering trough replaced.

November 20, 1914–
. . . said that she had talked with the manager of the local moving picture house and had found him willing to use the kind of pictures the women of the club would like, if they would let him know.

December 4, 1915–
Miss Amy Witherle reported that the Civics Committee was to work for a public dump and also to have drains connected with the sewer, their plan being to talk these matters up this winter and have an article put in the town warrant. They also plan to work for the improvement of motion pictures.

Miss Harvey spoke of attending a Christian Endeavor meeting where many children were unattended by their mothers, and appealed to all mothers to think the matter over.

"The popularity of the moving picture as a form of public amusement far from being on the wane is increasing by feverish leaps and bounds."[11]

1913—Quo Vadis
1914—Birth of a Nation
Charlie Chaplin tramp film

Two Castine men reminisce.
"Remember the Folly? Of course I do. I ran the projector."

41

Mary Pickford movies: "They were scary stories. She'd be tied to the railroad track or something. And then Prince Charming would come along just before the train came and get her loose."

"I frequently attended the Folly Theatre. I was in it the night Carpenter's ropewalk was struck by lightning and burned. Gladys Vague was providing background music on the piano. Might have been a 'pie in the face' comedy. Everybody rushed to the door, but there was no panic. Most stayed on the covered porch which ran the length of the building and looked down to the flames from the tar-soaked ropewalk. Two trusty pieces of fire equipment—Ajax, a tanker, and Hector, a pumper, were manned. Youngsters tried to join in; if they were very little, when the pump was elevated, it would lift the kids off the ground."

"When the Line & Twine factory burned, we had a barn full of cows. Had to go up on the roof with water; it was a hot fire."

February 5, 1916–
. . . voted to suggest name of Miss Gertrude Lewis for filling the vacancy in the Library Committee . . . to request the Trustees of the Library to ask the Town to add $100.00 to the Librarian's salary [club member Kate Davenport].
 Miss Harvey introduced the matter of a Mary Hooke Memorial: something to recognize her long service for the children in Castine. A case of children's books with plate attached to be placed in the library had been proposed as an appropriate memorial.

1916 Town Report.
"There have been several changes in the teaching force, made necessary by the death of Mary Hooke, the oldest teacher in point of experience, and one of the most conscientious teachers in this town—a teacher not only loved and respected by those under her charge, but by every person of the town."

"Of a buoyant temperament, imbued with a love of the small child, never fretted by the naughty deeds of her unruly little subjects, she managed them with a gentle firmness that brought results. . . . It was a pretty sight to see the children group around their teacher at the annual exhibitions and at the Campfire given by the G.A.R. Post each Decoration Day, when the Primary School was sure of an invitation to take part in the program."—*History of Castine* (1923 edition, p. 431)

"The children were crazy over Mary Hooke. Every Memorial Day in the evening they'd recite and sing at the town hall. The Grand Army would be on stage. Twelve or so of the children would lead her down the street from her house, hanging onto her dress tails."

"There is a Children's Corner (in the library) in memory of Mary Witherle Hooke, who taught the Primary School in Castine, nearly forty years. The fund for this Corner was raised by the Castine's Woman's Club. They have placed $500 at interest to supply the yearly quota of books, after having filled the shelves with approximately three hundred dollar's worth of books at the beginning."—*History of Castine* (1923 edition, p. 406)

1918 Town Report.
"The same organization subscribed for the *Boy's Life* and *Popular Mechanics.*"

February 5, 1916–
Miss Kelley reported for the Civics Committee. Their work has been to interest people for a public dump, to clear up rubbish, to remove old herring weirs, to have a fire police with a number of young men trained to help take out furniture safely in time of fire, to have a glass box for the key of the Congregational church, so the window need not be broken in case of fire, to improve the spiral stairs of the Grammar school.

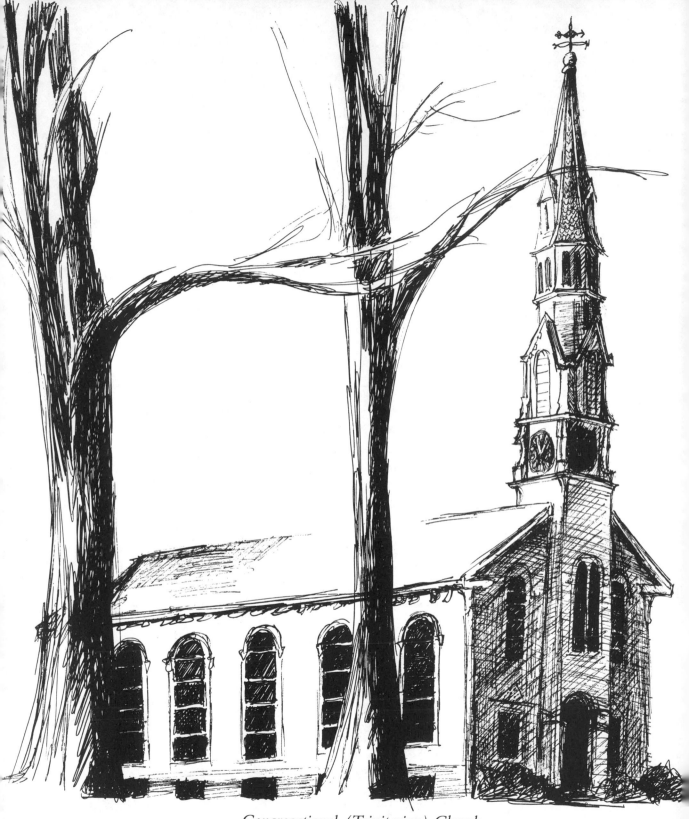

Congregational (Trinitarian) Church

The Club voted to buy a glass box for the church key.

Mr. Seybt requested that we announce that he expects to have "The Christian" in moving pictures and hopes our Club members will attend.

October 23, 1916–
The Civics Committee reported its successful efforts in cleaning up the waterfront—putting the steps in the Wharf in good condition, clearing away burdocks, placing the rubbish barrels, and putting a railing by the stairs in the grammar school building.

The object of this club shall be . . .

"Literary and Social Culture"

November 7, 1913–
lecture on food sanitation.

November 29, 1913–
lecture and book on sex hygiene. Mrs. Perkins plans to show later to all who are interested.

February 7, 1914–
The first paper, "Sex Hygiene," was given by Mrs. Perkins. This was an excellent paper, and many favorable comments upon it were heard later.

Sanitation and health were vital issues to women's clubs nationally. The General Federation crusaded for the Pure Food and Drug Act of 1906, which passed after a stormy campaign, and was amended in 1912, 1913, and 1919. Dr. Harvey W. Wiley, first Bureau chief, gave credit to the Federation for its passage.

Sex may have been a "distasteful necessity" to some of the ladies and popular publications advised restraint. "It is exceedingly bad manners for a girl to slap a man on the back, or lay a hand upon him in any way, or for him to touch her except for a friendly handshake." [12]

But sexual hygiene was of intense interest. Two books roused public indignation over prostitution and disease. Wright Kauffman's *House of Bondage* (1910) was the story of an innocent country girl, seduced and then syphilitic. *My Little Sister* (1913) by Anglo-American actress and writer Elizabeth Robins told of two young English girls lured to prostitution in London; it sold out four editions. At the GFWC Biennial in 1910 ("a deeply impressive conference")[13] women physicians spoke on the horrors of VD. The Federation passed a resolution urging state laws that would effectively prohibit White Slave traffic, approved the reporting of venereal diseases to Boards of Health, asked the Children's Bureau to distribute sex hygiene leaflets to children. The "little ones were receiving polluted information, especially in the public schools."[14] That same year Congress passed the Mann Act, which forbade the transportation of women across state lines for immoral purposes. In the next five years forty-five states made it illegal to make a profit from sex. And in 1914 the American Social Hygiene Association was formed to work on legislation and sex education.

But you could go too far. Public health nurse Margaret Sanger was jailed for opening a birth control clinic in Brooklyn in 1916.

Times *were* changing. Theda Bara movies were openly sexy; corsets were on the way out along with chaperones; public smoking was coming in.

> "The mothers had a lot to say about smoking," explains an elderly member. "It wasn't considered ladylike and was a part of that being protected business."

> "Men want a girl who has not rubbed off the peach blossom of innocence by exposure to a rough world," a writer cautioned.[15]

Vernon and Irene Castle's graceful fox trots were acceptable to club women, but fearful that more daring dances might enflame the senses and lead to promiscuity and disease, the General Federation in 1914 banned the Argentine tango and the hesitation waltz.

March 7, 1914–
Program: Italy. There were many pictures and post card views of the places visited by Miss [Amy] Witherle which were greatly enjoyed.

May 2, 1914–
The advantages of having a walking club were presented by Mrs. Hale. [Physical fitness programs for women were popular.]

December 5, 1914–
Program: "Household Drudgery and its Effect Upon Health."

February 6, 1915–
Program: "the Brownings."

47

April 2, 1915–
Program: "Mexico," at Emerson Hall, by Prof. Tubbs of Bates College (who had been in Mexico for five years twenty years ago). The lecture was most enthusiastically received by the entire audience.

Mexico's revolution in 1911 against dictator Porfirio Díaz, who welcomed American business, aroused the United States.

"Shall the property of American citizens be confiscated without being paid for?" demanded Calvin Coolidge.

"The capitalists are trying to drive me into war with Mexico," claimed President Wilson.[16] For several years fighting between Mexican liberals and conservatives continued; U.S. policy toward them was confused.

December 4, 1915–
Mrs. Philbrook organized a Musical Society having as its object the uplift of the community. Already two community sings have been held.

February 5, 1916–
A letter was read from the Chicago Woman's Shelter asking for $1.00 and describing briefly their work. Voted to respond as requested.

March 4, 1916–
300th anniversary of Shakespeare's death . . . voted that we act with the Shakespeare Club . . . [At a later meeting] the Club presented Mr. Charles Richmond from Ellsworth at an open meeting at Normal Hall, his subject being Shakespeare's Workshop. His talk was illustrated by maps, pictures, and model for the Globe Theatre. The Normal students are most grateful to the Woman's Club for the opportunity to hear Mr. Richmond. In two hours we came to know Shakespeare as a man and a great actor, rather than just as a schoolroom "bugbear."

May 15, 1916–
A lecture was given by Mrs. Kate B. Ellis on "Household Sanitation." The lecture was held in Emerson Hall and the Public

was invited. All were much interested in the pictures thrown on the screen and the various points brought out by Mrs. Ellis.

April 4, 1917—
The chairman of the Civics Committee announced that the play *The Old Peabody Pew* is to be given this spring.

Subject for debate—Resolved: that the children of the present day are not as responsible as the children of two generations ago . . . a very animated discussion followed.

January 18, 1918—
Gentlemen's Night. Speaker of the evening was Mr. Boyd Bartlett who gave a short sketch of Kipling's life and also read selections from his prose and poetical works, which was much enjoyed by all present.

November 2, 1918—
After a short recess Mrs. Grace Knudson gave a very interesting talk on "Aesthetic Japan."

December 7, 1918—
Mr. Hindus will give a lecture on life in Russia at the Congregational vestry.

Russian Czar Nicholas II had abdicated in March 1917, and a provisional government had been appointed. By November the Bolsheviks, headed by Lenin and Trotsky, had overthrown Kerensky, head of the provisional government. Civil war followed (until 1920) between the Reds (Communists, as the Bolsheviks came to be called) and the Whites (anti-Communists of various shades).

"Oh, yes. The town was against the Reds," an old lady says firmly.

January 4, 1919—
Speaker: Miss Lilla Severance gave a most interesting talk on her educational works among lighthouses. Miss Severance is the

only woman in the world to be engaged in such a work. She was given a rising vote of thanks.

January 7, 1919–
The lecture which was to be given by Mr. Hindus, had to be given up on account of the epidemic.

In ten months in 1918 half a million Americans died from flu.

October 18, 1919–
Mrs. Bartlett will lead the Current Events class again this year.
The President asked each member to come to the next meeting prepared to give the nationality of her great-grandfather, with the idea of finding out why we are Americans.

December 30, 1919–
On the above date a concert was held at Emerson Hall. The program consisted of Indian legends, dances, songs rendered in a most delightful manner by the Indian Princess Watahwaso.

The General Federation set up an American Indian Welfare Committee in 1921. Said a Sioux woman, Sitkala-Sa: "It has begun. Nothing now can stop it. We shall have help." [17]

Civic Improvement and Literary and Social Culture didn't preclude . . .
"Merriment"

December 4, 1915–
Program: "Woman's Club Journal"—living pictures portraying literary, fashion, music, and dramatic sections. Advertisements: Baker's Chocolate, Old Dutch Cleaner, vacuum cleaner, Eastman Kodak.

March 4, 1916–
Tea and cakes were served at the Executive Board meeting, which caused all the greater enjoyment because it was a surprise.

June 3, 1916–
Forty-three members and friends of the Castine Woman's Club enjoyed a picnic at Polly Coots Camp. The party arrived in launches about eleven o'clock. It is impossible to describe the pleasure which the day gave to all. Perfect weather and a chance for each to do as she chose contributed much toward our satisfaction. Some climbed John Brown's Mountain, others roamed the woods, and still others rested and talked on the broad piazza. The remainder of the afternoon went very quickly and soon we were obliged to say goodby after a day in every way refreshing.

February 3, 1917–
Annual Luncheon. A few were kept away on account of severe weather (18° below in the early morning). Dainty place cards were made by Miss Harvey. Miss Harvey also led in the singing of songs between courses, which added much merriment to the occasion.

February 23, 1917–
Mrs. Hooke presented the following list, which we record for the perusal of other committees preparing a luncheon—an estimate of amount required based upon our experience February 3.

Menu for 60 Persons

18 to 20 grapefruit
2 lb. sugar
cherries–bottle 50¢

6 qt. scallops or oysters or 6 fowl
6 qt. cream sauce
5 lb. potato chips
15 doz. rolls
6 glasses jelly
1 *large* qt. pickles
2 lb. butter

Dessert

3 gal. ice cream or sherbert
6 doz. macaroons
6 doz. cocoanut cakes
1½ lbs. coffee
2 eggs
2½ qt. cream
1 lb. lump sugar
2½ lb. candy

Caddie Walker's Cocoanut Cakes

2 cups corn flakes
2 egg whites beaten until stiff
scant cup of sugar

pinch of salt
⅔ package of cocoanut
teaspoon vanilla

April 6, 1917–
Executive Board meeting. A cup of hot tea with delicious sandwiches and chocolate cake put us in a happy frame of mind in spite of stormy weather.

June 7, 1919–
39 members and four guests of the Castine Woman's Club met at the Torii Shop for the annual club picnic. The location of the shop [on the Bagaduce River with a view into the Bay] made it an ideal place for a picnic, and although the sun refused to shine, there was no lack of sunshine within. Several of the ladies enjoyed a social chat, their fingers busy with knitting or crochet, while others roamed at will the attractive rooms, examining the attractive Japanese novelties.

Back to serious business . . .

"Our Unfortunate Sisters"

February 6, 1915–
The matter of the need of a State Reformatory for women in Maine was presented and the club voted to endorse the petition and forward same.

December 7, 1918–
On motion of Mrs. Philbrook the Club voted to send the following recommendation to the Federation:

> The members of the Castine Woman's Club believe that the name "Woman's Reformatory" given to the Institution at Skowhegan for the purpose of helping their unfortunate sisters, does not voice the spirit of modern Sociology. Those who have been reclaimed should be spared the suggestion that they had once been the inmates of a "corrective institution."

It is earnestly desired that this matter be brought before the coming Federation and a committee chosen who will be prompt in bringing it to the Legislature.

The Great War

In 1908 the rebellious "Young Turks" forced restoration of the constitution of 1876 and in 1909 deposed the Ottoman Empire sultan. At war with Italy and other countries between 1911 and 1913, Turkey lost most of its European territory. In 1913 a coup d'état gave Young Turk Enver Pasha dictatorial powers. In World War I he joined Turkey to the Central Powers (Germany and Austria-Hungary).

Seized by Ottoman Turks in the sixteenth century, Armenians had always been persecuted for their religion (Christian since the third century); even so, as merchants and financiers, they gained a vital economic role. From 1894 to 1915 they were victims of a

55

systematic plan of extermination, especially in 1915 when, accused of helping Russian invaders, one million were executed. Mothers all over America tried to make their children feel guilty about leaving food on their plates by reminding them of "the starving Armenians."

November 29, 1913–
Mrs. Patterson said that she would give some time in January a lecture on "Turkey" at which a silver collection would be taken for the benefit of the Armenian girl.

On June 28, 1914, Archduke Francis Ferdinand of Austria-Hungary was assassinated in Sarajevo by a Serb, and World War I began. In August Austria-Hungary's ally, Germany, invaded Belgium.

February 6, 1915–
The civics committee reported the work accomplished for Red Cross and Belgian relief.

From the *Bangor Daily News,* May 3, 1915, war news: "British and Germans in Running Naval Battle," "Ten Million Face Starvation," "Three Fourths of Towns and Villages in Poland Have Been Destroyed."

Not all thoughts were of war.

murders: ". . . a boarder in the home of Charles Carey, who is alleged to have murdered "Big Charles" Obszewski last Wednesday night, then placing his body across the tracks of the Maine Central railroad tracks—was on Saturday night locked in Lincoln jail."

movies: "Girl detectives are becoming favorite figures in picture plays. The latest recruit is Ruth, and she longs for adventure."

car accidents: ". . . a sausage manufacturer, and six children ran into a ditch and tipped over. He had recently purchased the car

and was taking the family for an outing celebration in honor of the birthday of one of the children."

February 5, 1916–
The President described some work which she proposed to do for the European War hospitals, and invited those interested to come to her home Friday P.M.

March 4, 1916–
A letter was read from the French War Hospital Fund Committee expressing their appreciation of the generous box of pillows and other supplies sent by the Woman's Club but made by the Campfire Girls and other friends.

October 23, 1916–
A letter was read from the Bureau for assisting the French wounded, asking for help. Miss Anna Witherle described the comfort bags. The Club voted to spend $3 for materials to be made into pads and pillows for the hospitals—the Campfire Girls to make up the same.

April 6, 1917—the United States declared war against Germany.

April 7, 1917–
. . . voted that Our Club display the flag and support our Government in any way we may be called upon to do.

"In April of 1917 ten patriotic women started a Special Aid Chapter, a branch of the national society. Mrs. Boyd Bartlett was elected chairman; Mrs W. A. Walker, secretary; and Mrs. George A. Benjamin, treasurer. During the summer, by the advice of Mr. J. Howard Wilson, this chapter added to its name 'Comforts Committee of the Navy League.' The specific task asked of Castine women was to fit out with knitted comforts the crew of the gunboat *Castine,* which in peace carried 112 men, but the number had been augmented to 212. . . . Mrs. C. Fred Jones was the efficient chairman of knitters, and there were sent to the *U.S.S. Castine* 148 sweaters, 152 mufflers, 171 wristlets, 127 helmets, and 81 pairs socks."

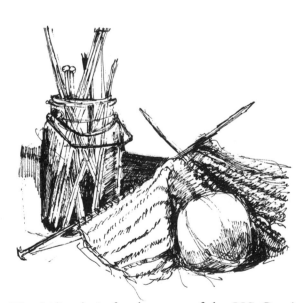

The ladies knit for the crew of the US Castine,
"a small but graceful gunboat."

Dear Madam:

The 112 sets of woolen comfort outfits that you turned over to Mrs. Asserson for the ship that bears the name of your town, have come and been distributed to the officers and men, so that now everyone on board has a complete outfit. I, myself, the other officers and men of the ship have already had occasion to wear and get the benefit out of the garments, and from the remarks the officers have made to me and not only from the sentiments expressed by the men, but also from the happy and contented looks on their faces that I have noticed when they go on watch on cold, stormy days and nights, I know they have the same kindly and grateful thoughts and feelings, that come to me, for the busy hands that have made all these things. We are grateful also for the loving thoughts and high sense of duty that inspire the womanhood of our country to give their thoughts and time, perhaps at great inconvenience to themselves, to this work, in order that the armed forces of the country in distant places may, as I have said above, keep warm and in good health and wear a happy and contented look on their faces and gratitude in their hearts for the women at home who are so busy for them. In behalf of the officers and crew of the *Castine,* please accept and express to the other ladies of the town, your co-workers, our heartfelt thanks, not only for the outfits but for the kindly thoughts behind them.

Very gratefully yours,
W. S. Asserson, Commander,
U.S.N. Commanding *U.S.S. Castine.*
[*History of Castine,* 1923, p. 396]

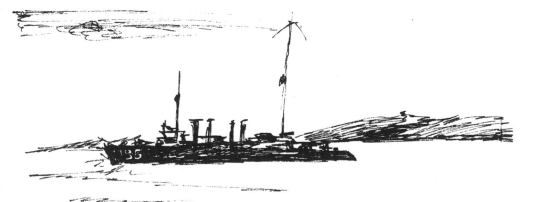

59

October 20, 1917–
Mrs. William Hooke told us about the tin box fund for the poor children of Belgium of which she is chairman for the state of Maine. On motion of Miss Bills it was voted that the Club give $5 to be used for the fund.

November 3, 1917–
A Committee was appointed to investigate the Red Cross movement.

December 1, 1917–
Miss Anna Witherle gave a very interesting report and thought it would be nice for us to start a Branch here, if agreeable to all, but didn't think it was necessary to have the Red Cross Branch and Special Aid—both.

Mrs. Boyd Bartlett gave a very good report of the work done by the Special Aid. She said that we had raised and given by donations $337 and had supplied the *Gunboat Castine* with sweaters, helmets, wristlets and scarfs.

February 2, 1918–
Miss Witherle asked for volunteers (for Red Cross work) to mend and refeet socks sent from Camp Devens.

The Club sang the "Marsaillaise," and then the President introduced the speaker for the P.M., Miss Anna Witherle, who gave a most interesting paper on France and the United States. Miss Witherle was given a rising vote of thanks.

March 19, 1918–
Mrs. Wescott read a letter from one of the boys at Camp Devens, who had received one of the books sent by the Club. She also spoke of forming a Junior Red Cross sometime in the near future. Program: a very interesting paper on the "Beginning and Purpose of the Red Cross."

A "Three-Day School" was held at the Normal School by the Agriculture Extension of the University of Maine. The program was in accord with the war times and was very interesting and instructive.

Eastern State Normal School

April 8, 1918–
Communications were read from the General Federation of Women's Clubs telling of the fund to be raised to establish furlough houses in France. It was voted to send $5.

May 4, 1918–
Mrs. Bartlett announced that the current events class and Red Cross Tea would be held at her house Monday P.M. at 4:30.

November 2, 1918–
Mrs. Wescott reported that $92 was received from the motion picture "Stella Maris." $72 was used for care of our orphan for two years . . . the remainder to the Tin Box Fund. Miss Jellison suggested that Miss Ellen P. Johnston write a letter to the little orphan.

October 18, 1919–
A most interesting letter from our French orphan was read by Miss Nellie F. Harvey.

November 7, 1919–
A letter was read by the Secretary from the Children's Tin Box Fund announcing that their work would end on November 1, 1919, but that the French child with whom we are corresponding should be supported by us for two years from the date on which we were given the child's name.

October 15, 1921–
On motion, it was voted that we send the same amount again this year to help our French orphan. This makes four years of assistance, and our orphan girl (Marie) will then be about 15 years of age.

The
ATEST MOTHER
in the WORLD

Our Boys

March 19, 1918—
The Secretary read the list of boys in the U. S. service from
Castine, and the President asked the ladies to take the names and
write to the boys.

September 19, 1917

"I guess that we will go over to France all right. If we come
back, it will certainly be a wonderful experience."

> Bernard F. Bowden
> Camp Curtis Guild
> Boxford, Massachusetts

April 24, 1918

"Passed a ship to-day bound for the States & believe me the old
American flag at her stern did look great."

> Edmund Walker
> on board a troopship bound for France

May 17, 1918

"Returning from drill this morning I was very pleasantly sur-
prised to find on my blankets the Red Cross kit so thoughtfully
and kindly provided by the Red Cross of Castine.

> Dick Morgrage
> Aviation Section, Signal Corps
> Camp Greene
> Charlotte, NC

October 20, 1918

"Received your most welcome package of useful articles. . . . They are just what every boy or soldier needs. I can imagine how the boys over there would feel to receive a gift of the same sort. Although I am not one of the lucky ones to be there, I only hope I will be soon."

C. A. Sawyer
Camp Devens, Massachusetts

October 18, 1918–
Harold Philbrook [Toul Sector of front line of battle; St. Mihiel, Verdun, Meuse-Argonne] spoke to the club about his war experiences.

In the Meuse Argonne offensive alone 117,000 American soldiers lost their lives.

Armistice Day, November 11, 1918

"Those who were in Castine on November 11, 1918 will recall the impromptu celebration and parade, the ringing of bells throughout the day. And certainly the women who congregated in the front hall of my house early in the forenoon of that famous day were never in doubt as to how the day shall be celebrated. All these ladies had sons in the army or navy, and the signing of the Armistice and cessation of hostilities was for them an occasion for joy and thanksgiving. Mrs. Douglas, Mrs. Philbrook, Mrs. Steele, Mrs. Wescott, Mrs. Bowden, Mrs. Walker and others were there all fairly beside themselves with joy."

William A. Walker
Armistice Day speech
November 11, 1921

65

November 15, 1918–
Program: "Life at West Point," Lt. Wheeler Bartlett. "With the Red Cross Ambulance in Italy"—George Carpenter gave a most interesting talk on American works in Italy, in connection with the Red Cross—and told us a good many experiences which he had there, while in this work. He also showed souvenirs which he had obtained.

January 1, 1919

"We had a fine trip up to England and over to Dunquerque, France and got a trip up to the fighting lines and saw the battlefields of Ypes, Belgium. Everything was blown to pieces and not a building standing."

Albert D. McIntire
seaman

January 12, 1919

"I imagine that you are as happy as we are that the War is over for altho we have had some pretty tough times over here, it has not been all sunshine in the States. . . . We went in for the first time Feb. 7th, 1918 and was on the lines 6 months without a relief then we came out for about a month we were sent in again and stayed until the Armistice was signed . . . toughest fighting we saw was the last month of six weeks north of Verdun altho we had some pretty stiff scraps at Chateau Thierry."

Bernard Bowden
American Expeditionary Force in France

January 16, 1919

"As long as I have been in France I haven't seen your Son yet every place we go I look around to see if I could Find him but we all will be home soon."

Leslie B. Scammon
AEF in France

"The American town," commentator Eric Severeid wrote years later in *Collier's,* "was simply *home*—and *all* of it home, not just the house but all the town."[18]

<div align="right">February 18, 1919</div>

"Another month nearly gone and still no change . . . we are still drilling three hours each morning & using the afternoon for organized sports which breaks the monotony very well. . . . There is a dance for officers in Laval to-morrow evening, a lot of American nurses & French girls who dance very well. Went to one of their dances about 10 days ago & had a fine time. . . . Our division to parade in NY soon after its arrival. Try to get there—have an idea it is going to be a big thing."

<div align="right">Edmund Walker
AEF in France</div>

Although Caddie Walker was secretary at the time, the minutes of this next meeting are not in her handwriting. She must have wanted to listen to every word of the first speaker—her son Edmund, who was home from the war.

April 12, 1919–

After the business session Miss Harvey introduced two of our returned soldiers: Lt. W. E. Walker gave a very earnest and interesting talk on his experiences on the trip to France, his work in a camp for *intense* and *intensive* training in an artillery corps, which resulted in that wonderful, accurate gunfire which made our forces the admiration of the world and the despair of the German armies—and his service at the front in that last campaign culminating in the armistice of Nov. 11, last.

Maynard Douglas, bugler in the Headquarters Corps, gave a graphic picture of the life of a private on shipboard, in camp, in hospital, and in service in France with a fund of grim humor, and a fervidness of expression which intensified the lights and shades to the very comedy and tragedy of life and death and kept his hearers continually on the qui vive.

"That was a righteous war," an elderly lady says firmly. "People were behind it. It was on the opposite end of the scale from Vietnam."

End of the Decade

December 6, 1919—
Papers and pencils were passed, and the members were asked to write answers to questions concerning the Balkan States. The astonishing lack of knowledge on the subject proved that all needed the most interesting and instructive information given in the program to which Miss [Anna] Witherle gave the general heading—"The Balkans and the Eastern Question."

"The Eastern Question" had long referred to the political relations of certain European countries with the disintegrating Ottoman Empire. The "sick man of Europe" was a major European problem.

The first number was a map exercise given by Miss Hattie A. Wiggin, in which she compared the early and present position of the divisions in the Balkan Peninsula.

Miss Bessie Clark followed with an interesting paper on the beginning of the break up of the Turkish Empire, with the rise of Greece.

Whittier's beautiful poem "The Hero" was read by Miss Bills. Verses from Lord Byron's "Childe Harold" were read by Miss Adams.

Miss Witherle gave an interesting account of the further dismemberment of the Turkish Empire from 1872 to 1914, and the connection between the Balkan disturbances and the late war.

Mrs. Bartlett spoke of the Yougo Slavs and their conflicting interests in Italy. Miss Harvey read a very interesting peasant spinning song.

Miss Witherle called our attention to a map drawn by Miss Jellison in which she had marked danger spots, showing that even now the world is far from being "safe for democracy."

4 "SIXTY INTELLIGENT WOMEN" (1920–1929)

"The Castine Woman's Club is always strongly behind every cause for the good of the town with its backing of more than sixty intelligent women."— *History of Castine* (1923 edition, p. 393)

In 1920 women at last could vote. Liquor, timber, and beef lobbyists feared they would push for reform. Proponents of women suffrage hoped "housewifely traits" (thrift) would infiltrate the business of government. But the disillusioned postwar period was "a time of defeat and decay for social feminists."[1] The General Federation of Women's Clubs, like much of America, had a diminished interest in reform and welfare. GFWC withdrew from the liberal Women's Joint Congressional Committee, and some liberals dropped out of the Federation.

To be sure, Prohibition had passed in 1919, but without the votes of women. For years they had agitated for temperance; Maine's Neil Dow Law was passed in 1851. And when the 18th Amendment was ratified, two-thirds of the states already had laws controlling the manufacture, sale, and consumption of alcoholic beverages, caused in part by resentment of the ruthless behavior of liquor interests.

But what interested the ladies now? The nation's high illiteracy rate shocked them—five million in 1923. Due to GFWC efforts hundreds of thousands learned to read. Conservation mattered. "The appearance of the General Federation on the field was like the appearance of American boys on the battlefields of France,"[2] said the head of the National Forestry As-

sociation after passage in 1922 of an amendment to the Federal Water Power Act, making it impossible for individuals or corporations to file claims for water rights at national parks or monuments.

Outraged that the position of homemaker was not recognized by the United States Census Bureau, the women's clubs conducted a Home Equipment Survey in 1925 to document that status.

> The uneducated, underpaid apprentice of milliner or dressmaker, who carries no responsibilities, has rank in the census reports, which is denied the homemaker, who acts as purchasing agent, general manager, seamstress, and nurse for her family.[3]

Needless to say, the 1930 census recognized the homemaker. The Federation also urged minimum wage commissions for all states and an eight-hour work-day for women in industry.

Like most Americans, Federation leaders were uneasy about immigrants, feared revolutionaries. But unlike too many, their remedy was humane.

> We must make democracy more real by fairer laws and enforcements, better housing conditions, better health conditions . . . we must make the foreign-born in our midst believe in America and love her, and get into the great game with us.—Mrs. T. G. Winter, GFWC president-elect, 1920[4]

To some Americans all social welfare programs were suspect—Communist inspired. Mrs. John D. Sherman, 1924 president, was on guard, too, but against right-wing attacks on what remained for the Federation a serious concern. ". . . The women of the Federation must not be afraid of having their patriotism questioned when their purpose is the betterment of conditions of women and children."[5]

What occupied the Castine ladies?

April 14, 1923—"New Movement appeals to Woman's Clubs . . . were enlarged upon, as Garden Week, Better Homes in America, Narcotics, Birds, Plant-a-tree, all of which such good work the Castine Woman's Club wishes to endorse." Except for "Narcotics" it could have been 1913.

In time, aspects of the twenties best remembered now did touch Castine. Here as elsewhere, grown children had found jobs in big cities; they indeed, were a part of the "Lost Generation." Flapper daughters jiggled to jazz in Greenwich Village, bobbed their hair, danced the Charleston, mooned over Rudy Vallee, necked in cars, got divorced; sons played Mah-Jongg, mooned over Clara Bow (the "It" girl), ventured up to Harlem, made bathtub gin.

Bohemian writers and artists "discovered" Castine . . . and the ladies discovered them.

"That painter Waldo Pierce, he was a character," one chuckles. "Once he walked down Main Street to meet the boat and what do you suppose he was wearing? A regular business suit and bare feet!"

"There were always writers here in town. And some quite radical summer women came. So people knew about those things."

Writer Ellen Glasgow was popular. Near the end of her life she summered in Castine. "The people here think you so gay and attractive," someone told her, "that they wonder why you write such sad books."[6]

She was not the first writer to be inspected. Earlier observers had had critical words for Harriet Beecher Stowe when she and her son came to town in the 1880s, according to Lu Bartlett. "To the curious eyes of the Castine women, Mrs. Stowe wore her hair dressed in a rather frowzy style, and there was a careless

74

air in the way she put on her clothes, but much can be forgiven the woman who wrote *Uncle Tom's Cabin* and those delightful stories of Orr's Island, though a silent rancor has always lingered, because she did not incorporate Castine in a novel," according to the *History of Castine* (1928 edition), p. 359.

But Katharine Butler Hathaway was writing lovingly about Castine in *The Little Locksmith,* published in 1942.

> . . . I was delighted to hear in their voices the inflection which I had learned to recognize as one of the unique characteristics of Castine. Their voices kept going up and down, up and down, indulgent, humorous, and persuasive, no matter what the subject of the conversation might be. The effect of this inflection is that even in the most casual remark the inhabitants of Castine always seem to be insisting gently and humorously that they want to comfort you for everything and want to excuse you for all your faults. 'There, there, everything is all right, don't be frightened or upset about anything,' say the men's voices, as well as the women's voices, no matter what they are saying. I was crazy about that sound. It was just what I had been needing all my life to hear. I think of it as one of the physical elements of Castine, like the Castine air, which the inhabitants are so used to breathing that if they have to go away they discover to their surprise that they cannot breathe well in other places.[7]

The ladies of the Castine Woman's Club knew what was going on in other places. They knew about the Scopes trial on Darwinism in Tennessee and the trial and execution of anarchists Sacco and Vanzetti, victims of "The Red Scare." Movies by big-name producers with big stars like Rudolph Valentino, Douglas Fairbanks, and Gloria Swanson came to the Folly. Bootleggers were not unknown to Castine.

The first plane flew over town in 1922, and in 1927 the ladies thrilled to Charles Lindbergh's flight to Paris.

State and national Federation work gave them an opportunity to expand their own horizons.

April 14, 1923–
Miss Richards read an announcement and cordial invitation . . . urging delegates to attend the Biennial Council of Federated Women to be held in Atlanta. [In 1926 there were three million

members.] This meeting will afford an opportunity to hear the greatest woman speakers in the world.

"It was quite an honor if you were chosen to represent the club at a Federation meeting," an old-timer remembers.

The stay-at-homes kept their minds perking, too. Recruited from the Maine colleges, summer people, the State Federation, and their own members were speakers on a mish-mash of fascinating subjects. No, sir. There were still "no flies" on the ladies of Castine.

The Vote

"Sensible and responsible women do not want to vote. The relative positions assumed by man and woman in the working out of our civilization was assigned long ago by a higher intelligence than ours."—Grover Cleveland in *Ladies' Home Journal,* October 1905

19th Amendment—"The right of citizens of the United States to vote shall not be denied or abridged by the United States or by any State on account of sex."

1848—right of women to vote first proposed at Seneca Falls conference.

1868—suffrage in Wyoming.

1869—amendment introduced and defeated in House by Elizabeth Cady Stanton and Susan B. Anthony; later others tried in states.

1890—two suffrage wings united in National American Women Suffrage Association; Stanton first president, Anthony second.

1912—Colorado, Utah, Idaho, Washington, California, Oregon, Kansas, Arizona had full suffrage, as well as Wyoming. None in Maine or Rhode Island, partial in rest of New England. In New York City 15,000 women (and men) marched in the suffrage parade.

1913—National Women's Party began efforts for constitutional amendment, using votes of already enfranchised.

1914—GFWC endorsed (some of leaders were suffragists, but careful not to antagonize conservative members).

1915—40,000 marched in New York suffrage parade.

1916—GOP presidential candidate Hughes endorsed suffrage (but his party's platform did not); Wilson (who had always been against for chivalric reasons) praised in principle, preferred state action.

1918—Wilson urged passage of 19th Amendment as "vital to winning war" (suffrage groups were helping war effort).

1919—In June, Congress passed 19th Amendment by two-thirds vote; sent to states.

1920—Tennessee ratified on August 26, making three-quarters of the states. Secretary of State notified at 4 A.M., at 9 A.M. declared official . . . just in time for presidential election in November.

"I was against suffrage for awhile. Why was that?" an elderly lady strains to remember. "I thought you could use your influence without getting into the dirt of politics. There was something else—it had to do with being protected. Polling places were considered too rough for women. And there was a third reason. . . . It seems ridiculous now. I thought all women would be doing was doubling the vote, because they'd do what their husbands and fathers told them to."

February 7, 1914–
The remainder of the afternoon was devoted to discussion of the question "Extension of Suffrage to Women." Mrs. Carpenter: affirmative. Mrs. Devereux: negative. Vote: 8 (no) to 17 (yes).

"The first money-making scheme was the presentation of an extremely funny Suffragette Town Meeting."—Louise Wheeler Bartlett's history, written for the 20th Anniversary

November 7, 1914–
175 at open meeting at Emerson Hall (46 members). Speaker from Portland on "Woman's Suffrage."

June 3, 1916–
Miss Preston told us of her experiences during the campaign for equal suffrage in New York.

79

September 10, 1917—special Castine town meeting. "Shall the [state] Constitution be amended as proposed by a resolution of the legislature granting suffrage to Women upon equal terms with men." Yes–46; No–59.—Town Records

February 5, 1921–
A paper on "Political Work of Women" was read.

April 22, 1921–
Part of a letter from Miss Anna Witherle was read, asking the Club to back up Mrs. Philbrook as Overseer of the Poor.

April 4, 1922–
The President asked for a count of the registered voters in the club. Of those who remained for the business meeting 24 had registered.

November 3, 1923–
. . . letters from Clara Mullan, female candidate for Registrar of Probate.

March 15, 1924–
The latter part of the meeting was devoted to current events in charge of Miss Witherle. A paper of the Republican candidate [for Governor] Mr. Farrington, was read by Mrs. West and one on Mr. Brewster by Mrs. Hale. Mrs. G. Coombs gave an outline of the Democratic platform.

"Ralph Brewster taught here before he became Governor," chuckles an old-timer, "and straightened the high school out. He stayed at the Castine House, but John Vogel didn't send him a bill for two weeks. When Brewster asked why not, Vogel told him, 'Anybody who can straighten out John Gay [his bellhop] don't owe me a cent.'"

March 7, 1925–
The Club members were requested to sign a petition to the Legislature in favor of the retention of the direct primary bill.

November 6, 1926–
The next speaker was Arthur Patterson of Castine, who gave an instructive talk on some of the bills to come before the state legislature of which he will be a member.

"My brother Arthur who was attending University of Maine Law School at the time, had been active in campaigning for Teddy Roosevelt," reports Lilla Patterson's son Donnie. "He had a new Maxwell, open car with canvas top, and proudly drove it with T. R. during a parade through Bangor."

February 4, 1928–
A questionnaire was read from the General Federation, relating to the civic influence exerted by the Club as an organization and by the members individually. A show of hands revealed that nearly 100% of the members were registered voters and exercised the privilege of voting regularly.

January 5, 1929–
Miss Witherle moved that the Club award a local prize of $5 for the best essay and $2 for the second best on the subject of "Why I Should Vote."

March 2, 1929–
After the luncheon Mrs. Bartlett presented the three prizes to the High School students who had been invited to the luncheon. Eleanor Wescott was given first prize.

October 9, 1931–
Miss Martin, a member of the last state legislature, gave a very interesting and worthwhile talk on the Code bill. She explained the bill in a clear, straight-forward manner.

By the end of the decade Amy Witherle and Gertrude Lewis were trustees of the Castine library. Anna Witherle was on the Board of Health; Louise Bartlett and Gen Hooper served on the town's Public Grounds and Historical Committee.

The Federation

Satisfied Hostesses

September 14–16, 1921–
State Federation meeting in Castine . . . letter read speaking of the pleasant time held at Castine and how royally they were entertained.

Annual Report, 1921–22—The biggest thing we did during the past year was the entertaining of the State Federation. It was certainly an honor and a pleasure to the Castine Woman's Club to bring to our town so many women from all parts of the state. The delightful reception at the Acadian, with the wonderfully fine music brought pleasure to so many, the historical pil-

grimage conducted by Mr. Walker . . . and Mrs. Mary Devereux's fine paper on "Castine History" were unique features in a Federation meeting.

"One of the far-reaching events planned by the Woman's Club came off in September 14–16 of the year 1921, when the Maine State Federation of Woman's Clubs held its fall meetings in the historic Unitarian church. Some three hundred women took the town by storm on the afternoon of the 14th, but found the Castine Club ready to welcome them with a cordial reception in the music room of the Acadian Hotel. After the formalities had been

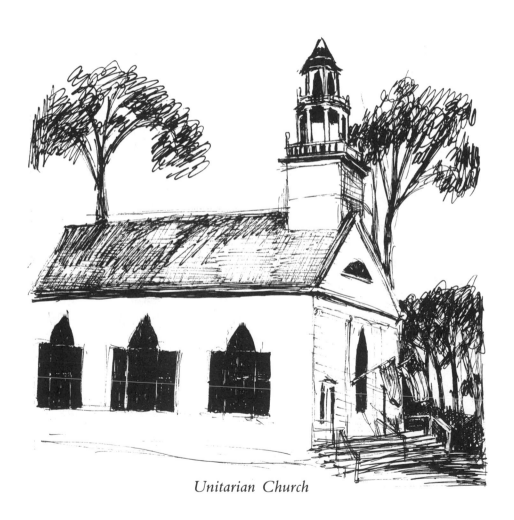

Unitarian Church

observed, members of the famous Kneisel family of musicians rendered a most artistic program. On the next afternoon, the Maine Writers' Research Club held its meeting; its membership includes among other things, an address by Anna Coleman Ladd of Boston, the sculptress, who did wonderful work in making masks for injured war veterans. This was the first occasion when the Federation had been entertained by a small town."— *History of Castine* (1923 edition, p. 385)

Bursting with Pride

June 10, 1925–
To the Clubs of the Maine State Federation: At the Autumn meeting in Bangor of the Maine Federation of Women's Clubs, will take place the election of new officers for the ensuing two years.

As a club we take pride in unanimously endorsing, for President of the State Federation, the candidacy of *Miss Anna Cate Witherle* of Castine, now First Vice-President.

Miss Witherle is already well known to federation clubs throughout the State, by reason of her active work upon the Executive Board during the past four years, and particularly for her recent splendid efforts in sale of our Federal pin and in behalf of Headquarters Fund.

Her thorough culture and wide outlook upon life; her familiarity with club activities national as well as state and town— and present position as First Vice-President, putting her in direct line for the higher responsibility; her residence in the eastern part of our State, alternation with a President from the Western half, are but several of the plain arguments—if arguments be necessary—pointing toward Miss Witherle as the logical, natural choice for next President of the Maine Federation of Women's Clubs.

We ask your support of her candidacy.

Fraternally yours,
Castine Woman's Club

84

October 12, 1925—
Mrs. Knudson, the new president, with the aid of Mrs. Bartlett, presented to Miss Witherle a silver tray from the club in token of their appreciation of the honor conferred upon them by her election. As president of the Federation Miss Witherle accepted the gift with appropriate remarks.

"Annie" Cate Witherle had graduated from Wellesley in 1896, did graduate work there in history and literature. For a few years she taught in Massachusetts and Maine high schools, returned to Castine to keep house for her widowed mother and settled there permanently after her mother's death.

"Now it is Togo the cat who keeps house for Anna," said the 1918 Wellesley alumnae notes, "so that she may be chairman of the Red Cross branch." It was a position she would hold until World War II.

"Yes," Miss Witherle had replied firmly to Wellesley's 1913 inquiry to its graduates, she did "desire the franchise." (Of her classmates 49 agreed; 31 didn't; 26 were "indifferent"; 6 already had it.)

By 1925 the fifty-two-year-old president of the Maine Federation of Woman's Clubs had served on a number of club committees, was a member of the Maine Public Health Association. During her two-year term she lived winter and spring in Bangor, traveled "over most of the branches of the railroads in Maine" making speeches; she attended GFWC meetings in other states.

Travel was in the Witherle genes. For Anna that included several voyages through the Panama Canal and across the Pacific to Honolulu to visit her aunt Anna Cate Dole, wife of former Governor Sanford.

In Castine Anna Witherle "used to have a girl each year from the Castine Normal School live with her," wrote a classmate. "In all she took a vital interest and kept in touch with them after graduation. She encouraged them to go on for further study and kept the high ideal of service, both by precept and example, constantly before them."

"Precise" and "kind" is how several Castiners remember Miss Witherle. Her "ideal of service" had been fostered at Wellesley where the influence of Professor Vida Scudder's college settlement movement remained strong. In the 1880s Scudder had called student volunteers to a "new Franciscanism." To Anna Witherle serving was being.

At the town's 1896 Centennial Anna Cate Witherle had read this poem by her aunt Anna Cate Dole, who was born in Castine. Anna Dole sent it across the ocean from her home in Honolulu, and Louise Bartlett quoted it in the *History of Castine* (1923 edition, p. 382)

Silently over the Bigwaduce
Daybreak is coming in tints of pearl,
Flushing the river with roses' bloom,
Making an opal out of the sea,
Where the fisher boats their sails unfurl,
Waking the world to a perfect dawn,
Just as a hundred years agone.
God still watches over thee,
O, beautiful town beside the sea!
Silently over the Camden hills
The sun is setting in seas of gold;
Folding the tired land to sleep
In a glory of colors manifold.
Wrapping thee close in a golden sheen,
God is watching thee—loved Castine!

Child Welfare

The infant welfare movement began in the late nineteenth century when private agencies opened stations for distribution of pasturized milk and, later, advice on prenatal and early health care for children.

In 1912 the United States Children's Bureau was established under the Department of Commerce (later, Labor) "to investigate and report . . . upon all matters pertaining to the welfare of children and child life among all classes of people, and shall especially investigate the question of infant mortality, the birth rate . . . and diseases of children." Woodrow Wilson made Julia Lathrop, an alumna of Hull House, its first president. The GFWC, which had lobbied for the Bureau, was delighted.

During National Baby Week in 1916 and 1917 the Federation recruited two thousand clubs to report on conditions of infant and maternal mortality, birth registration, and public health facilities.

This national movement struck a fervent chord in the ladies.

Summer, 1915–
Our feeling is of sadness [two members had died], but I am reminded of one of the resolutions passed at the State Federation meeting a year ago: "Resolved: that we make child welfare the measuring stick of our work." When I think of these two members—how one loved and worked for children all her life and the other gave her life for her child, I feel that our sadness should be superseded by an inspiration to work with a more cheerful, hopeful zeal for all children.

December 4, 1915–
Mrs. Captain Devereux reported that the Child Welfare Committee would continue their work as a Distribution Bureau, distributing especially shoes, stockings, and rubbers.

87

February 5, 1916–
The Child Welfare Committee reported clothing received and distributed, that the Committee had tried to interest people in a Parent-Teachers' Association and that plans were in progress to observe Baby Week March 4–11.

March 4, 1916–
The Child Welfare Committee reported that glasses have been obtained for . . ., the expense of which was only $2 because of the generosity of Chase and Doak.

 The committee also reported that Baby Week was to be observed by two papers to be read to the club and by the ministers from the pulpit on Sunday. The papers of the club were "Care and Feeding of Infants" by Miss Lewis and "The School Lunch" by Miss Coombs. Both were instructive and helpful.

June 4, 1919–
The question of the physical welfare of our children was brought up, and Mrs. Philbrook suggested that the scheme of weighing children often should be carried out here in Castine.

July 8, 1919–
A short talk by the President followed during which she stated the object of the Special Meeting as follows: To discuss and vote on plans for a Mid-Summer Carnival. She also called attention to the fact that on April 6th of this year was inaugurated Nationwide Children's Year, and suggested that the funds of the Carnival be devoted chiefly to various activities for the welfare of the children with which the Club is connected, including an increase of the Mary Hooke Memorial Fund, and that the Carnival managers advertise this object.

August 5, 1919 –

CARNIVAL

A Mile of Old Styles. A Town of New Smiles. It is hoped that old-style costume will be the garb of the day, but lack of such costume will not bar from any of the festivities.

Community Dress Parade — *10 A.M.*
Community Fair on the Common . . .
admission 10¢
Booths — *refreshments, fortunes,* candy (Temptation booths).*
　　** If you have forgotten the past (and want to remember it); if you are dissatisfied with the present; if you dare to question the future — do not hesitate to consult Madam — she knows much more than she will tell you.*
Exhibits — *household arts, antiques, posters effectively arranged in the Unitarian Parish House. 10¢*
Agriculture — *Emerson Hall. Vegetables like you see in seed catalogues, and the tools that make them grow that way.*
Juvenile exhibits in Emerson Hall
Baby Show on Common — *2 P.M.*
Band concert — *3 P.M.*
Ribbons and Prizes — *8 P.M. (Emerson Hall)*
Dance — *9 P.M. in old-style costume, if possible. Old Contra Dances and Quadrilles and Waltzes. Also Exhibition Dances.*

25¢

The End of a Community Day

May 1, 1920–
Speaker: need of children being taught simple rules of good health and the proper care of babies.

November 22, 1920–
Special Meeting. Resolved: that the Castine Woman's Club—numbering sixty-eight women of the community—most heartily endorse the so-called Sheppard Towner bill for the protection of Maternity and Infancy and that a request for the early passage of this bill in the session of Congress which convenes on December 6, 1920, be forwarded to the Maine Senators and Representatives in Congress.

The Sheppard-Towner bill for protection of maternity and infancy, which Congress passed in 1921, was administered by the Children's Bureau. It laid the groundwork for child health and welfare legislation in the states and the formation of maternal and child health bureaus.

Then the bill went to state legislatures.

February 24, 1923–
A letter was read from Senator Sargent about the Sheppard Towner bill. . . . There was mention by our President of a creditable speech by the only woman member, Mrs. Dora Bradbury Pinkham, Ft. Kent, who mothered the measure.

Voted to send telegrams to the senators and representatives of this state endorsing the Sheppard Towner Bill. . . .

Child Labor

In the early 1900s there were one and a half million children under the age of sixteen working up to thirteen hours a day in textile factories and sweat shops. By 1913 twenty percent of the nation's children were employed, and the number was growing.

The average family earned eight hundred dollars a year and needed the income.

"Why don't you play?" someone asked a child laborer.

"I don't know how," was the reply.

A factory foreman claimed, "We don't have accidents. Once in awhile a finger is mashed or foot, but it does not amount to anything."[8]

Senator William Borah of Idaho was outraged. "It is time for government to do for children what it has already done for calves and pigs," he declared.[9]

The GFWC shared his sentiments, urging its members to lobby for state and national legislation. It was tough sledding. Congressional child labor laws were declared unconstitutional in 1918 and 1922; a child labor amendment passed in 1924 but was never ratified by the states. Refusing to give up, the GFWC urged clubs to push for state laws that conformed to Federal standards.

January 3, 1925–
A paper on the Child Labor Amendment was presented in a masterly manner by Mrs. Grace Knudson, who brought up for club inspection the various arguments of the many-sided matter.

"Breaking the News to Coolidge" and Other National Matters

November 5, 1921–
Mrs. Bartlett read extracts of a letter received from her daughter-in-law, Mrs. Wheeler Bartlett, giving her impressions on her first visit to Congress. It was very witty and amusing and much enjoyed by the club. [Helen Allen Bartlett, the oldest living member of the Castine club, had joined in 1915, when she was a young teacher at the high school.]

November 3, 1923–
The members were asked to cast a straw vote for the next president of the U.S.A. Coolidge won . . . Mrs. Harquail gave an interesting account of the life of Warren G. Harding dealing especially with the instances that showed the humility of his life.

A paper of breaking the news to Calvin Coolidge was read by Mrs. John Gardiner. Mrs. William Hooper read some interesting sketches from the life of Calvin Coolidge. . . . A paper on the Ku Klux Klan was read.

1924 election (Castine)

Republican candidate for President	182
Democrat	37
Socialist Labor	0
Progressive	3

Ku Klux Klan

In 1915, the Reconstruction era, white supremacy Ku Klux Klan had been resurrected by a Southern preacher. In 1922, a KKK promoter empowered hundreds to recruit members at ten dollars each, keeping four dollars for themselves. Playing on anti-Catholic, anti-Jewish prejudice as well as anti-black, they signed up one hundred thousand members in the north as well as the south. (In Torrington, Connecticut in the 1800s a church member had kept watch in the steeple of the brand new Roman Catholic church, fearing an attack by "Protestants and the Ku Klux Klan.") In spite of a *New York World* exposé of sadistic brutality, membership by 1924 was about four million. Klansmen practically took over the state of Indiana.

But the next year a girl in Indianapolis poisoned herself, accusing the Grand Dragon for Indiana of rape. His conviction turned the tide; membership plummeted.

January 5, 1924–
A request from the Isaak Walton League of America asking that the Club urge its congressmen to vote for the 300 mile Upper Mississippi River National Reserve bill. The Club voted to have the Secretary write the congressman expressing an interest in the bill.

March 15, 1924–
The club members voted to favor a federal prison for women.

December 5, 1925–
A newspaper article concerning the referendum on daylight saving and the grading of milk was read to the club.

March 7, 1931–
Miss Florence Paul, on the committee for Beautification of Roadsides, sent a communication asking the Club to take a vote on a resolution concerning the taxation of billboards and send the resolution to Senator Foster. The Club voted in favor of the resolution.

Rural Mail Carriers' Horses

*1924–*Whereas in many rural regions horses are still used on mail routes in the winter and are often poorly cared for, overloaded and over-driven—and whereas the United States mail team, often the only representative of the national government in rural regions, should be an honor to the government, instead of a disgrace, as it too often is—

"We respectfully petition the Postmaster General to have the inspector of the post office department take account of the conditions of the horses used on mail routes, and require persons leasing mail routes to provide suitable horses and to give the horses humane treatment and proper food and care."

Castine Post Office

International Affairs

The Armistice had restored Poland as an independent state. Russia was to be given large parts in the east, but Poland objected, and war broke out in 1920.

November 5, 1920–
An incident of conditions in Poland was read by Miss Harvey.

The Treaty of Riga in 1921 restored most of the territory. War continued between Turkey and Greece, however. In 1922 after Mustafa Kemal (later known as Ataturk) drove Greek forces out of Asia Minor, he expelled one and a half million Greeks from ancient communities on the Black Sea and the Aegean. In retaliation Greece ordered out all its Moslems.

Near East Relief was organized and privately financed to feed and clothe these and other refugees, to build houses, and set up schools and industries. One-quarter of the $91 million raised in money and $25 million worth of food went to Russia, where civil war had brought famine and disease.

June 3, 1922–
An appeal was made for old clothing for the Near East Relief.

March 10, 1923–
Much interest was shown in the discussion of current events.
. . . Miss Amy Witherle gave a clear summary of the work of
Congress and Mrs. Knudson gave an interesting discussion of
the complicated situation in the Near East.

Article 14 of the Covenant of the League of Nations created in
1921 a Permanent Court of International Justice at The Hague.
In spite of the urgings of several presidents, the United States
Senate refused to join.

January 4, 1930–
It was voted to adopt the resolution urging the Senate to ratify
without delay the protocol to the subject of entrance of the
United States to the World Court.

"Definite endorsement of America's entrance into the World
Court by the Board of Directors of the General Federation of
Women's Clubs has been characterized by the Washington press
as 'one of the most significant steps yet taken in women's politi-
cal history.'"[10]

"Oh, yes . . . the World Court. I had such hopes for that," an
early member recalled sadly.

December, 1928–
Reading and explanation of the Kellogg Multilateral Peace
Treaty—Club voted to accept.

The Kellogg-Briand Pact condemned "resource to war for the
solution of international controversies." Named for United
States Secretary of State Frank Kellogg and French Foreign Min-
ister Aristide Briand, it was ratified in Paris in the summer of
1928 by fifteen nations; eventually sixty-two nations signed it,
including Italy, Japan, and Germany. The United States Senate
ratified the treaty with only one negative vote on January 15,
1929. No way of enforcement was provided.

97

November 20, 1929–
After the business of the meeting Miss Witherle introduced Mr. Cecil Fiedler who gave a most interesting talk on Gandhi and India and his work there.

Mahatma Gandhi was in the middle of his nonviolent resistance campaigns for a free (from Great Britain), united India, the revival of home industry (especially the textile industry), and the abolition of the caste of untouchability. In 1930 Gandhi was imprisoned for violating the government's salt monopoly but was released in 1931 to attend the London Round Table conference on India as the only representative of the Indian National Congress.

But the big international event of the decade for the ladies (and the entire town) was the visit to Castine from Australia of Colonel Castine and his family, descendants of the Baron.

December 1, 1923–
Program: Australia, piano solo, "The Geography of Australia," Reading: "Old Man Kangaroo," "History and Government of Australia," Reading: "Why Uncle Sam Riles Australia," Solo: "Song of the Emigrant," "Percy Granger," Australian poetry.

"At Emerson Hall a crowd had been waiting for more than an hour. It was near 10:30 o'clock when Selectman Patterson introduced Dr. Philbrook, who delivered an address of welcome to which Colonel Castine responded and told the audience something about his home land of Australia and its people and their customs.

"Hon. William A. Walker in behalf of the citizens of Castine presented to Col. Castine a painting by John Parker, a new resident of the town, one of the most renowned historical painters of America, depicting the departure of Baron Castin and his

Emerson Hall

bride from the town. It was with difficulty that Colonel Castine mastered his emotions sufficiently to reply." [11]

International affairs were important, but the ladies still worked at . . .

Keeping the Town "Tidy"

April 2, 1920–
remarks by the President concerning means of junk disposal in Castine.

November 5, 1921–
The Civics Committee brought up a discussion in regard to raffling and gambling and the keeping open of stores on Sunday in town. A motion was carried that the Woman's Club would stand behind the Civics Committee in their efforts in any moral or right thing along community betterment.

June 3, 1922–
Mrs. Hooke, Chairman for the Civics Committee, reported that this committee was working to have calcium chloride put on Main Street to lay the dust during the summer and perhaps to extend this around Walker's Corner at lower Main Street and on to Mr. Ricker's Store on Water Street.

February 24, 1923–
Attention was called to an act by the Department of Education to provide for a celebration in March, to observe Temperance Day in the public schools in the state of Maine.

June 5, 1926–
Mrs. Charles Devereux was appointed chairman of a committee to interest the children in removing caterpillar nests from the trees.

100

April 26, 1931–
Mrs. Danforth, Chairman of the Civics committee, reported that the town line post had been straightened and that Mr. Stover was ready to work on the gardens at the foot of the flag pole on Main Street and Dyer's Lane and that any plants for the same would be gratefully accepted.

February 2, 1936–
. . . voted also to give $35 to the Civics Committee to be used to pay a man to keep the streets and public grounds tidy.

The New Community Hospital

"In 1914, Dr. H. B. Webster, of Boston, who had settled in Castine two years previous, in looking about for a house suitable to be remodeled into a private hospital hit upon the long time home of H. W. Dresser . . . and by the addition of an operating room and sun parlor, a larger heating apparatus and fresh paint, soon made a model little hospital. When America entered the World War, Dr. Webster entered the service and in his absence installed in his hospital Dr. Harold S. Babcock. Before the close of 1918, Dr. Webster was called upon to make his final sacrifice for his country, and the property passed into the hands of the resident surgeon, Dr. Babcock. It has now been incorporated as the Castine General Hospital. . . . For a small hospital it is well supplied with electrical equipment and surgical instruments. Several of the latter have been gifts from the Woman's Club."—*History of Castine* (1923 edition, p. 406)

". . . On August 5th of 1920, special preparations having been made by committees of the town and the Woman's Club working in unison for the two-fold purpose of holding a carnival and celebrating the centennial of Maine's admission to statehood, the Woman's Club presented an historical pageant that was the equal of any staged in the state during 1920. . . . With the natural advantages of a perfect day and the setting of the stage for the pageant on historic Fort George, success was assured. . . . The receipts were large and used for the benefit of hospital and library."—*History of Castine* (1923 edition, p. 384).

October 18, 1919–
. . . voted that $100 be pledged to the Castine Hospital toward the purchase of an X-Ray machine, and that $41.75 be given to Dr. Babcock for the immediate purchase of an electric sterilizing machine for the hospital.

October 15, 1927–
Mrs. Babcock asked the support of the Woman's Club in furthering a drive to provide for the starting and up-keep of the New Community Hospital. A discussion followed in which it

was agreed that this was a very worthy cause and needed all the support which the Club could give.

September 30, 1930–
It was voted that the Board recommend that we put aside $100 to be used for the Castine Community Hospital with the idea in view that a room be marked with the name of the club and that we devote our services toward that room. October 4—it was so voted.

February 7, 1931–
Mrs. Babcock announced that a special bed, very nice mattress, Specialists table, Mayo Instrument Table, two modern chairs had been purchased by the Club for the maternity room at the Hospital at a cost of $100.75. Mrs. Babcock also said that the subject of extra bedding, spreads, blankets, etc. could be discussed at a later date.

April 14, 1931–
It was reported that the hospital was in need of a few baby clothes, and Miss Staples suggested that she would be glad to have her girls at the Normal School make a few simple clothes if material could be provided.

Self-improvement remained important. Programs were invariably . . .
"Instructive and Interesting"

February 14, 1920–
Program: "Lowell's Love of Nature," "James Russell Lowell and the Questions of His Day." Miss Harvey closed the program with a witty quotation.

April 2, 1920–
Program: "Junk, Thrift, & Housecleaning."

November 5, 1921–
Book reviews by Miss Kate Russell in which she gave a summary of a lecture on Modern Poetry given by Prof. Ellis of the University of Maine at the State Teachers' convention in Portland. Also a review of a recent book *The Brimming Cup* (1916) by Dorothy Canfield [Fisher]. This was listened to with intense interest.

March 4, 1922–
. . . the speaker of the afternoon, Miss Abbie Buck of Orland. Miss Buck spent three months abroad last summer, the guest of her brother, who is connected with the Rockefeller Fund of France. Miss Buck chose for her subject "The Peasant Life in France."

The Rockefeller Foundation was founded in 1913 "to promote the well-being of mankind throughout the world." It finances programs in public health and research in the medical, natural, and social sciences.

February 24, 1923–
The National Federation is sending out reading matter to American women, making a plea, encouraging the study of chemistry.

November 3, 1924–
The Club enjoyed a poem by Amy Lowell.

January 3, 1925–
Mr. Edmund Booth of Dartmouth College was introduced as the Reader. The poems of Robert Frost were his subject.

"The January meeting of the Castine Woman's Club was held at the home of Miss Amy Witherle. It was a snowy afternoon and the wide hall of Miss Witherle's century old house opened up a most hospitable vista for each member, hurrying in from the too eager touch of the snow-fraught air. . . . The subject of the scholarship fund was broached. This helps support girls in normal school or college. As Maine is said to dispute with Oberlin the honor of first admitting woman within the sacred portals, the club unanimously voted $5 to the fund.

"A request for knitted articles for Dr. Grenfel's mission met a generous response. Books were asked for the state prison library, recently destroyed by fire. Thanks were received from the Maplecrest Veteran's Sanitarium for the Christmas gifts from the Castine club.

105

"The chairman of the study committee then briefly, but brightly introduced the main speaker of the afternoon, Edmund H. Booth of the English department of Dartmouth College. Mr. Booth last June married one of Castine's fairest and most popular daughters [Elizabeth Hooke's daughter Jean]. This was the first public appearance of the young couple and Mr. Booth received a more than cordial welcome. His subject was Robert Frost, poet, and he said his intention was to let his audience learn the manner of man he was, from his poems. . . . Mr. Booth said in his short appreciation that Frost was a master of blank verse, that he talked rather than sung.

"He was a poet of rural life, the special voice of New England rural life and depicts the loneliness of the farm in all its pathos, the drudgery of the farmer's wife, the sweet neighborliness of the little village, with its comedies and its tragedies. It would be a mooted question as to whether Frost's poems would retain universality and permanence. Mr. Booth spoke easily with a choice command of language, and to many of the audience his words more nearly approached the true heart of literature than the poems that followed. Mr. Booth read in a most sympathetic voice the following poems: "A Time to Talk," "The Tuft of Flowers," "Birches," "Mending Walls," "The Woodpile," "Death of the Hired Man," "Home Burial," and "A Hundred Collars."—*Bangor Daily News* (1925)

February 5, 1926–
Program: "Running an Oil Burner."

October 15, 1927–
A program was carried out in observance of National Picture Week. An interesting feature was a discussion of Jessie Wilcox Smith's works. Other painters: Raphael, Corot, Michelangelo.

January 7, 1928–
The program was in the form of a delightful piano recital (Bach, Beethoven, Chopin, Elgar, Straus, Dvorak) given by Mrs. Mueller. Her rendering of the well chosen selections was polished, interpretive, and wholly artistic.

April 13, 1929–
The speaker of the afternoon, Frederick Pierce, talked on "The Evolution of the Brain." The lecture was both instructive and interesting and full of practical suggestions.

March 1, 1930–
Mrs. Philbrook introduced Dr. Philbrook who gave a very interesting talk on the beginnings of Opera. He made his talk more interesting and more helpful by playing victrola records.

March 9, 1931–
The subject of the program was "The Song of the Slave—Its Development and Influence on American Music." A most interesting paper on "The History of American Music" was read by Mrs. Mueller after which the following musical numbers were rendered, each number being preceded by a few words of explanation: "Nobody Knows the Troubles I'se Seen," "Getting Ready to Die," "Song of the Auction Block," "Keep Me From Sinking Down."

The music of the Jungle was illustrated by two piano solos played by Mrs. Mueller. . . . Its modification in Creole selections. Mrs. Mueller explained why ragtime music was so called, after which she played "Georgia Campmeeting" and Mrs. Macomber played "Whistling Rufus."

October 7, 1933–
Assembled at the Wilson Museum and while observing the fine cultural exhibit there, were privileged to listen to a most instructive and enjoyable lecture by Dr. J. Howard Wilson.

"Properly Garbed"

April 16, 1921–
Miss Allen read a very interesting paper on "Costume Design-ing." She illustrated this by showing first the type of girl who is improperly garbed for marketing, luncheon, and theatre, etc. After that came the girls who were dressed correctly for their various activities.

"Oh, I used to love the Woman's Club. Everybody who was anyone belonged . . . until (as my sister said), 'we plebians got in.' We used to get all dressed up in hats and gloves. If you had a new dress, you saved it for the annual Woman's Club lun-cheon," a woman remembers.

"Better Homes"

December 2, 1922–
The subject of the lecture, "The Atmosphere of Better Homes," was accompanied by an art exhibit, which Mrs. Knudson has especially prepared for the Maine State Federation. It was a most interesting collection of household furnishings of various kinds, with the idea of giving help in interior decoration. The Castine Club felt especially favored in having Mrs. Knudson, one of its own members, personally deliver her lecture.

The Depression had not yet touched Castine. So the ladies indulged in some . . .

"Very Entertaining" Meetings

February 7, 1920—
Gentlemen's Night at the Castine House. A short recess was declared after which nine of the Club ladies presented the Negro farce: "Mrs. Black's Pink Tea," and at the close of the entitled farce the colored troupe gave a combination Virginia reel and cake walk.

The summer before there were race riots in Washington. Marcus Garvey began his nationalistic "Back to Africa" movement.

April 2, 1920—
On motion of Mrs. Philbrook it was voted that we should have a club color. A rising vote was taken, and "yellow" was the color chosen by a large majority.

May 1, 1920—
The tables were prettily decorated with jonquils, the yellow color scheme being carried out in flowers, place cards, napkins and the waitresses's caps.

June 5, 1920—
Annual picnic at Golf Club House. The heavy rain, which everyone realized was so greatly needed, rather added to the enjoyment of the occasion, and all felt that the picnic had been every way a success.

January 14, 1921—
A most delicious supper. (Gentlemen's Night). Fish chowder, scallop stew, crackers, pickles, bread and butter.

November 5, 1921—
Program: "Art of the Garden" illustrated with stereoptican. [The Masons loaned the lantern.]

112

November 4, 1922–
Mrs. Philbrook sang very effectively two of James Whitcomb Riley's songs. The club and normal school students were particularly delighted with her rendition of "That Old Sweetheart of Mine."

December 23, 1926–
Miss Nellie Harvey gave an illustrated talk on the Sesqui-Centennial recently held in Philadelphia. The club members felt that the next best thing to attending the Sesqui-Centennial was to hear Miss Harvey talk about it.

February 5, 1927–
At the close of the luncheon the name of some person in the public eye was pinned on the back of everyone present. From conversations with his neighbor each was to guess whom he represented. Mrs. Harquail with the name of Edward Bok, received the first prize.

Edward Bok was editor of *The Ladies' Home Journal* from 1889 to 1919, won a Pulitzer Prize in 1920 for his autobiography, contributed to peace programs, Princeton, and Philadelphia Orchestra broadcasts to schools.

"It's all right for a woman to join a club provided she joins merely one and does not place its interests, in importance, before the higher duties of the home"—Edward Bok, "My Quarrel with Women's Clubs," in his own magazine.

1928 **June** Annual picnic at the Babcock bungalow in North Castine. Place and weather ideal and everyone was in true holiday mood. The meeeting was interrupted by the rapid approach of a thunder shower, and the ladies hurriedly adjourned to the roomy living room. Conversation was enjoyed while windblown rain swept the building outside. The shower lasted but a short time however, and because of the beautiful light effects and the changing blues and greens of the river and landscape, it seemed to have been arranged and part of the entertainment.

113

November 7, 1929–

. . . the speaker of the evening, Miss Anna Kitridge of Belfast, a newspaper writer of many years experience. Miss Kitridge proved to be a person with a charming personality and a bright and witty speaker. Her work has given her a wide acquaintance among interesting and famous people—Lady Astor, the famous Millay sisters, Prime Minister MacKenzie King of Canada, and Teddy Roosevelt.

"EDUCATION FOR A CHANGING WORLD" * (1930–1941)

January 4, 1930–

"Mrs. Joseph Devereux's pleasant, cheery house was the meeting place of the Ladies of the Castine Woman's Club in January."

The previous October the stock market had crashed; although much of the country was unemployed, the Depression had not yet hit Castine with full force.

But nationwide, clubs sprang into action to feed the hungry. The GFWC supported cooperative farm markets which sold surplus products. Millions of quarts of food were canned and distributed by club members; milk was supplied to countless schools. In cooperation with the Department of Commerce a "wise spending" program was inaugurated "to uncover opportunities for consumer cooperation in solving consumer-relations problems in business."[1] Weekly consumer broadcasts were made with the Department of Agriculture.

April 5, 1930–
"Miss Witherle gave out a notice about the Census Enumeration which was to begin in April, and urged all the ladies to give it a few minutes thought before the Enumerator should call so as to be prepared with the answers."

How much had America changed, the government needed to know? Certainly there were fewer farmers. In Castine the

Program for a 1930s meeting.

number of horses was down to 48 (from 107 in 1913), cows to 78 (from 129), sheep and swine to 0 (from 42 and 55). There were more cars, of course. In 1913 carriages had been assessed at $4,385, autos at $3,750. Now there were no carriages and 155 cars. Folks drank more; after fourteen years, prohibition was repealed in 1933. Hundreds of people were returning to small towns. In 1920 Sinclair Lewis had lambasted their values in *Main Street,* but over a decade and a half later Thornton Wilder's *Our Town* was a hit.

Radio had become a part of daily life.

December 8, 1934–
"Mrs. Hooke presented a petition for signatures of interested persons. This petition was directed to the Central Maine Power Company requesting better radio service, which has been most unsatisfactory because of poor wiring in some sections of the town."

The ladies listened to household and child-care advice, laughed at Jack Benny, Fred Allen, and Amos 'n' Andy. They tuned into Walter Winchell ahd Gabriel Heater broadcasts of distant news: John L. Lewis and labor strife, horrible lynchings (one every three weeks in 1935), ghastly murders, sensational trials. But Kate Smith sang cheerful songs, Tin Pan Alley tunesmiths set their feet tapping, Toscanini and Paderewski brought classical music.

The husbands groaned, as they endured the radio "Fireside Chats" of "that man in the White House." But the ladies admired adventuresome Eleanor Roosevelt, discussed her magazine column "My Day." Although good writers had been writing short stories for popular magazines, a 1933 survey of five journals reaching 36 million women found the fiction "bloodless and sentimental." (At the Castine library were *Grapes of Wrath, Gone With the Wind, The Good Earth.*) During a sixth-month period there were "no articles on power control, immigration, farm problems, economic planning, child welfare, education, the labor movement, taxation or international affairs. Peace and governmental economy were honored with one article each."[2]

The General Federation of Women's Clubs was accused, too, of superficiality. Business and professional women established their own more pertinent organizations; few farm women were represented the Castine club had a solution to that; attitudes toward women workers were maternalistic (benefits without basic changes).

The Federation did support government efforts toward conservation, such as the National Resource Board's studies of watersheds, flood control, forest resources, soil and wind erosion. President Grace Poole's administration sponsored forums on all

sides of issues, such as birth control, the equal rights amendment, old age pension, unemployment insurance, foreign policy. Socialist candidates for office were invited to speak, as well as Republicans and Democrats. During the presidency of career woman Sadie Dunbar, the Federation lobbied for uniform marriage and divorce laws, control of narcotics, and peace.

Noncontroversial topics, such as folk art, were encouraged. The federal government had begun the Index of American Design, and the Castine ladies studied old clocks and clockmakers, old samplers and coins. Labor-saving machinery for home and farm was being perfected; the cotton picker and sugar cane chopper-reaper put southern field hands out of work. Air conditioning, prefabricated houses, automobile trailers, television, plastics, and cellophane had been invented, if not marketed, by the end of the decade. The Castine ladies listened to a club program on "Invention and American Life."

But they were hardly "superficial." As the Depression deepened, the New Deal expanded, science advanced, health care became institutionalized, and World War II loomed, the ladies of Castine paid attention and cared.

"Needy Families"

"The Depression was very bad here," a club member remembers. "We didn't feel it until a couple of years after they did in the city. We depended on work for the summer people to save enough to get through the winter. Salmon was only 9¢ a can, but you didn't always have that 9¢.

"There was a fund to help people. A nurse—she was short and chubby; can't remember her name—she knew who needed help without people knowing.

"When R. got rheumatic fever, Dr. Babcock said he couldn't work for three months.

"'What am I going to do?' I asked him.

"'I don't know,' he said. 'But you'll manage.'

"And he was right. It was the most amazing thing. People

would come by with a pot of soup and say it was extra. Or they'd bring $5 and say, 'I owed R. this.' I never knew if they really did."

December 5, 1930–
It was voted that the club appropriate $5 toward the Christmas baskets to be given out in co-operation with the Lions Club.

January 9, 1931–
Mrs. Danforth spoke about the Christmas baskets and thanked the members for their generous contributions of food and money.

February 7, 1931–
It was voted to give $5 to the Red Cross for Drought Relief.

The Great Plains was turning into a Dust Bowl.

April 18, 1931–
One of the most delightful meetings of the year was held in conjunction with the Farm Bureau at the North Castine Grange Hall. The ladies of the Farm Bureau served their famous "Square Meals for Health," charging only twenty five cents a plate. The menu was Delmonico Potatoes, cold boiled ham, pineapple and cabbage salad, hot rolls, prune pudding, and ice box cookies.

February 19, 1932–
A discussion was held concerning a call for help from families in town. Miss Harvey gave ten dollars to be used through the Club for baskets or milk, as the Board saw fit. It was favored to ask the Club to allow the Board to spend one half of the sum saved from the luncheon (or seven dollars and fifty cents) at their discretion for charity work. It was voted to send a five dollar basket of groceries to one family and a pint of milk to another (for two months).

May 14, 1932–
On the above date the Castine Woman's Club and The Woman's Branch of the North Castine Farm Bureau held a joint meeting at the vestry of the Federated Church. Miss Barney, the Home Demonstration agent, held a very interesting discussion on "Know Your Groceries."

November 4, 1933–
Miss Barney, Home Demonstration agent, gave a very instructive talk on "The Second in the Series, Know Your Groceries." Miss Barney was assisted by several of the Farm Bureau members. The discussion was quite animated at times and the Club members found the program very worthwhile.

January 13, 1934–
Miss Edith Bean, reporting for the Civics committee, said that her committee had secured yarn and Mrs. Will Mayo was knitting mittens for needy children in town. Miss Anna Witherle reported on the Christmas baskets. Fourteen families were cheered by the combined forces of Woman's and Lion's clubs. The Red Cross flour was sent with each basket this year. . . . Following an investigation of Civil Works Administration jobs in town it was found that there were none open to women.

> "You may be sure that under the new Civil Works program women will not be overlooked," announced Mrs. Ellen S. Woodward, director of CWA's women's work at a press conference. A program for unemployed women was hammered out at a White House conference called and keynoted by Eleanor [Roosevelt] and attended by the leading figures in the field of social welfare. By the end of 1933, 100,000 women had CWA jobs.[3]

March 2, 1935–
The Club sang the General Federation song "America the Beautiful" by Katharine Lee Bates [a Wellesley classmate of Lilla Patterson]. First selectman W. A. Ricker spoke on the relation of the Federal government to local affairs. This was one of the most interesting talks the Club members have heard this year.

1928	Hoover and Curtis	218 (R)
	Smith and Robinson	66 (D)
	Socialist	6

1932	Hoover and Curtis	216 (R)
	Roosevelt and Garner	97 (D)
	Socialist	1
	Socialist Labor	2
	Communist	0

1936	Landon and Knox	231 (R)
	Roosevelt and Garner	88 (D)
	Socialist	6
	Communist (Browder)	1

1940	Wilkie and McNary	227 (R)
	Roosevelt and Wallace	114 (D)
	Socialist	2
	Communist	1

June 1, 1935–
It was voted to pay a sum, not to exceed $5 to Miss Conant to be used to buy stockings etc. for High School Seniors in need.

February 6, 1937–
Miss Anna Witherle asked for second-hand clothing that might be made over for those who are needy.

February 4, 1938–
The club voted to give $10 to a deserving woman.

December 7, 1940–
Mrs. Ricker was called upon to explain the surplus commodities and to read amounts given by government and distributed in

Castine during the past six months. Mrs. Bartlett made motion to have a written ballot to decide on Christmas baskets. It was voted by written ballot to discontinue baskets for this year 1940.

The government was stepping in. So were the national health care organizations.

Sickness and Health

Medical science made great advances in the first third of the century. Infant mortality declined; so did death rates for tuberculosis, typhoid, diphtheria, measles, and pneumonia. Yellow fever and smallpox were almost wiped out.

December 5, 1931—
Mrs. Bean reported that the sale of seals for the Society for Crippled Children had begun and many were being sold to help the cause.

December 5, 1936—
Miss Louise P. Hopkins, RN of Bangor, described the work that is being done in Bangor for tubercular patients in the sanitarium, open-air school, and summer camp.

February 27, 1938—
The Board felt that the Helen Keller drive for the blind could not be carried out this year, as the club already gives to so many worthy causes.

April 9, 1938—
Mrs. Philbrook spoke of the cancer drive, requesting all to donate their 10 cents for this most worthy cause.

April 22, 1939–
It was voted to give $5 to the Woman's Field Army for Cancer Control. $2 for the Infantile Paralysis Fund.

Federation leaders had been chosen by the American Cancer Society to form this auxiliary. Up until now cancer was a subject not discussed by ladies.

One government representative was warmly welcomed.

Mrs. Roosevelt Comes to Town

July 24, 1935–
A special Board Meeting was held at the home of Miss Anna Witherle at 3 P.M. Plans were made for a reception in honor of Mrs. Franklin Delano Roosevelt to be given at the Library. . . . It was decided to ask several Club members to act as ushers, Miss Lewis, Miss Bean, and Miss Amy Witherle to arrange for flowers to place about the Library, and Miss Anna Witherle to introduce our honored guest.

"How can we have a reception for a Democrat?" a club member had wailed to Louise Bartlett.

"That's not what we're doing," Lu soothed her. "We're having a reception for the President's wife."

July 26, 1935–
In our beautiful Town Library at 2:30 P.M. a reception was held in honor of Mrs. Franklin D. Roosevelt, the wife of the President of the United States.

Miss Anna Witherle presented Mrs. Roosevelt, who was also accompanied by Miss Mary Dewson, whose guest she was while in Castine. The group stood at the end of the reading room, which was decorated by many beautiful flowers.

Several members of the Club were in constant attendance in order that there should be no confusion among the many who came to greet Mrs. Roosevelt.

Summer visitor Molly Dewson was head of the Women's Division, Democratic National Committee. In the forties she was a member of the Castine Woman's Club.

"My father couldn't stand Eleanor Roosevelt until she came here," an elderly member reports with a smile. "Then he fell in love with her."

127

Witherle Memorial Library

"Information Please" and Other Amusements of the Time

December 3, 1932–
Two plays, Barrie's "Twelve Pound Look" and a one-act play by Oscar Wilde were presented in a most entertaining and delightful manner.

April 22, 1935–
Program: old songs. Origin and History of "When You and I Were Young, Maggie," "Reuben and Rachel," "Danny Boy," "Last Rose of Summer," "Annie Laurie," "Drink to Me Only With Thine Eyes."

When You and I Were Young, Maggie

I wandered today to the hill, Maggie,
To watch the scene below.
The creek and the old creaking mill, Maggie,
Where we used to sit long ago.

The green grove is gone from the hill, Maggie,
Where first the daisies sprung,
The creaking old mill is still, Maggie,
Since you and I were young.

Reuben and Rachel

Reuben, Reuben, I've been thinking what a fine world this would be
If the men were all transplanted far beyond the Northern sea.

Rachel, Rachel, I've been thinking what a fine world this would be
If there were more charming women right here by the Northern sea.

Reuben, Reuben, I've been thinking, life would be so easy then.
What a lovely world this would be, if there were no tiresome men.

September 24, 1936–
First on the program was a game—guessing the names of the characters represented in the Comic Strips. Those who could not guess the name of the character at her place was asked to pay one cent—the money to be given to the cracker fund for the school children. This was followed by guessing advertisements.

"Who should get 'Goofy'? Mrs. Hooke, of all people!" hooted a club member. "She was disgusted. 'How should I know?' she said. 'I never read the comics.'
"'You should,' Molly Scott told her. 'Some of them are very interesting.'"

By May 1937 the Works Progress Administration (WPA) had spent $46 million on the arts (the same year France spent $6 million).

> The early music of Mexico and Texas was collected on the plains and the border, Acadian and Creole songs in Louisiana, African songs sung by the Negroes of the Mississippi bayou, the folk songs of the Southern mountaineers, white and Negro spirituals from the Carolinas, settlers' songs and songs of Indian origin from Oklahoma, early Spanish songs from California, liturgical songs from the California missions, songs sung by the Penitentes of New Mexico, music brought into Mexico in the time of the conquistadors.[4]

November 7, 1936–
Miss Anna Witherle reported on the concert which was sponsored by members of the club, given by the American Church Institute for Negroes ["the colored people of the South"] at the Acadian Hotel last summer. Speaker of the afternoon was Rev. Clifford Peaslee of Belfast, whose subject was Contemporary Drama. In a very pleasing, forceful way Mr. Peaslee described the following plays: "Tobacco Road," "Dead End," and "Idiot's Delight."

131

March 6, 1937–
Musical program: Gershwin's "I Got Plenty of Nuttin'."

May 6, 1939–
The Club met at the lovely home of Mrs. H. S. Babcock. Spring poems were read by two ladies very daintily dressed in delicate colors of crêpe paper. They passed to each member a delightful nosegay of sweetpeas and foliage. Mrs. Charles Devereux reported that the drive to advertise New England to World's Fair visitors was progressing satisfactorily. Miss Anna Witherle gave a very interesting talk on her visits to the San Francisco Golden Gates Exposition. This was followed by a splendid word picture of the New York World's Fair by Mrs. Ermo Scott—thus making us all wish we might attend them both.

"Once Alice and I wore crêpe paper dresses," laughed a club woman. "Wasn't that corny? We thought we were the cat's meow; we weren't kids, you know."

January 13, 1940–
Speaker: Mrs. Nelson Canfield, who had read Christopher Morley's *East of Eden* and Maurice Maeterlinck's *Bluebird*.

March 2, 1940–
Rev. Harold Metzner of Waterville gave a very interesting talk on the life and the plays of Eugene O'Neill.

August 1, 1940–
The annual summer club day was held at Emerson Hall. Food and candy were sold during the afternoon. In the evening the hall was filled to capacity. The Castine band, conducted by Willis A. Ricker, rendered three selections. This was followed by "Information Please" with R. B. Dinsmore as announcer and Prof. Edmund Booth as master of ceremonies. The board of experts consisted of Miss Dorothy Blake [summer visitor], Mrs. Randall Hilton [wife of the Unitarian minister], Mrs. Margaret Ames [summer visitor], Sidney Greenbie [author and teacher],

Rev. John Brigham, and Dr. W. E. Mikell [dean of University of Pennsylvania Law School]. For every question missed a sum was donated to the Red Cross. This money was rung up on Mrs. A. W. Clark's cash register by Prof. Booth. A prize, a copy of the *History of Castine,* was donated by Mrs. Boyd Bartlett. Mrs. Ames was the winner of the history.

The final number of the program was the Woman's Club Sub-Deb orchestra. The ladies produced an unbelievable amount of "music" from instruments made of kitchen utensils.

Spring was always a pleasure.

"Fashion Trends for Spring"

June 6, 1931–
Annual picnic at the home of Miss Josephine Wescott at North Castine. Tables were arranged on the porches and lawns and a pleasant spot was found for each member whether she preferred sun, shade, breeze, or calm.

June 3, 1933–
Annual picnic at the attractive home of Mrs. Sidney Greenbie. A delicious luncheon was served in the Orchard, under a canopy of apple blossoms.

April 2, 1935–
A very nice program was given as follows: Vocal duet. Reading. Fashion show. Game. The tea table was joyous with daffodils.

March 8, 1941–
Miss Mann gave a practical talk on fashion trends for spring, illustrating her talk with the showing of new styles in dresses, suits, and capes brought from shops in Bangor.

Silver Anniversary Tea

February 5, 1938–
Sixty-nine women of Castine and Penobscot observed the Silver Anniversary of the Castine Woman's Club at their annual Club luncheon, held in the Parish House at 1 o'clock on the above date.

A delicious menu consisting of the following was served by an efficient committee dressed in white with little aprons bordered with silver and gold: cream of mushroom soup and crax, chicken patties, potato chips, green peas, tomato and pineapple salad, hot rolls, cream puffs filled with vanilla ice cream and covered with hot chocolate sauce, coffee and mints. A beautiful angel birthday cake of two large layers decorated with white icing, silver candies and 25 miniature lighted candles was presented to the Club. This was cut by the "Club Mother," Mrs. William Hooke, founder of the Club in 1913, and each member had a piece. The silver bordered napkins were in keeping with the occasion. Vases of spring flowers were in profusion among the tables. These were later taken to members unable to be present.

Program: Baby Picture Guessing game. Singing by Club members: "On Moonlight Bay." History of the First 20 Years of the Castine Woman's Club written by Mrs. Louise Bartlett. Remarks by the "Club Mother." Greeting from absent club members. Memorial Service for Charter members. Dialogue, "In Mrs. Bartlett's Kitchen 25 Years Ago." The enacting of the first Woman's Club meeting was postponed on account of the lateness of the hour. Mrs. Philbrook (President) presented Mrs. Hooke with a bouquet of spring flowers with appropriate remarks.

"That was a gala affair," an old-timer remembers happily. "We spent $50 on the flowers and decorations. Oh, dear, I remember Evelyn Danforth wanted shoestring string beans from Bangor because they'd be more elegant. But we couldn't afford them."

"My Trip to Honolulu"

"The sea-captains and the captains' wives of Maine knew something of the wide world, and never mistook their native parishes for the whole instead of a part thereof. They knew not only Thomaston, Castine, and Portland, but London and Bristol and Bordeaux, and the strange-mannered harbors of the China Sea," wrote Sarah Orne Jewett (1849–1909), in *Country of the Pointed Firs*.

January 5, 1929–
Miss Anna Witherle gave a most interesting talk on "The Hawaiian Islands."

April 5, 1930–
This being a South American meeting, Miss Witherle invited Mrs. Bartlett to take charge of the program: 1. Spanish Dance. 2. Geography Introduction to South America. 3. Capitals of the

North. 4. Brazil and her capital. 5. United States of South America. 6. The Spanish language. 7. My Trip to South America [written by Mrs. Annie Connor, wife of a ship's captain]. 8. South America looks at the United States. 9. South America and her schools.

November 7, 1931–
Chairman of the Education Committee presented the afternoon's speaker Mr. Sydney Greenbie, president of the Traversity, an organization which is known as a travel university for young men and women. Mr. Greenbie spoke on his experiences in South America. He also touched upon the Manchurian situation. Everyone enjoyed his talk very much.

Japan had invaded Manchuria in September 1931. In January Secretary of State Henry L. Stimson told Japan that the United States "does not intend to recognize any situation, treaty, or agreement which may be brought about contrary to the covenants and obligations of the Pact of Paris" (Kellogg-Briand). The League of Nations condemned the action but could do no more. Japan withdrew from the League, and militarists made plans to invade China. Chiang Kai-shek, strong man of the Nationalist government, appeased the Japanese and fought rival Chinese Communists, who, in turn, fought the Japanese.

January 9, 1932–
Chairman of the Study Committee introduced Mr. Philip Von Saltza, speaker of the afternoon. Mr. Von Saltza was born in Sweden, which fact made his talk doubly interesting. He traced the effect the Nordic races have had upon the European races. He began with the ancient times, tracing the history of Sweden through the early centuries up to and during the Thirty-year War (1618–48). It was the opinion of a great many club members that a series of lectures following up this subject would be of great interest after Mr. Von Saltza had given such a splendid background for the study.

137

February 4, 1933–
With a few well-chosen remarks the President introduced Mrs. Sydney Greenbie as the speaker of the afternoon. Mrs. Greenbie spoke in a most charming manner on "Life of White People in the Far East."

After Lenin's death in 1924 Stalin had defeated Trotsky and others in a power struggle. The first Five-Year Plan for agriculture and industrial growth had begun in 1928. For years the United States refused to recognize the USSR, but finally did so in 1933. The next year Russia was admitted to the League of Nations. By then literacy was up, and medical and social services had expanded. But all education and public information were under state control, and Stalin's purges were under way.

January 5, 1935–
The Rev. Mr. Randall Hilton told of his visit to Russia. This was very interesting and most instructive. A rising vote of thanks was given Mr. Hilton for his splendid talk.

"He sounds like a Communist," one member remembers another complained.
"Let him get $100 in his pocket," said Lu Bartlett, "and he'll sing a different tune."

Hitler's Nazi party received under a million votes in the 1928 election, 6 million in 1930 (second largest), almost 13½ million in 1932 (largest). Hitler had himself named chancellor and assumed dictatorial powers in January 1933. In February rival Communist party members were beaten, jailed, and tortured. In September of 1933 the first of the annual, week-long party rallies was held at Nuremberg with half a million people and frightening spectacles of pageantry, speechmaking, and goose-stepping soldiers and paramilitary youth groups. The next month Hitler withdrew Germany from the League of Nations

and the Geneva Disarmament Conference. Secretly the army had been building for years; now Germany rearmed in open defiance of the Treaty of Versailles. In the fall of 1934 a second rally was held at Nuremberg.

October 18, 1935–
At the close of the business, Miss Lewis introduced Mrs. Wheeler Bartlett who spoke on "Last Winter in Munich" and showed many interesting pictures with the kind help of Charles Parker, who operated the picture machine. Mrs. Bartlett's talk was very much enjoyed. A rising vote of thanks was given for a most interesting and instructive evening. Thanks was also given to Charles Parker.

May 4, 1936–
The speaker of the evening was Prof. Marion J. Bradshaw [Bangor Theological Seminary], who gave us a splendid talk of his travels through Japan. This lecture was accompanied by beautiful colored pictures. The picture machine was operated by Mr. Nason.

March 4, 1938–
Miss Witherle then gave an illustrated talk on Bermuda, assisted by Mr. Olson at the machine. This was greatly enjoyed by all present, and by the beautifully colored scenes and descriptive comments of the speaker, one could almost live in reality what she conveyed to us in her own travels so pleasingly told.

April 9, 1938–
It was voted that the Woman's Club pay one half of the transportation expenses of the Japanese girl who is to speak at the Normal School. Wendall Haldock gave an illustrated talk on the Maine Indian and Mt. Desert Island.

February 2, 1940–
Anna Witherle talked on "My Trip to Honolulu" illustrated by lantern slides.

"Unfortunate War-stricken China" . . . and Europe

The Ladies were, of course, aware that shadows were passing over the sun.

December 6, 1937–
It was voted that we, as a club, express our disapproval of the actions of the Japanese government by refraining from using imported goods from Japan.

At the end of 1936, Chiang Kai-shek had been "kidnapped" by his own officers; he agreed to join Mao Tse-tung's Communists in fighting the Japanese, who were taking control of coastal cities and moving up the rivers inland. The United States Neutrality Act of 1935 had made unlawful the sale of arms to belligerents, but not until the summer of 1940 did Washington ban the sale of strategic materials (cotton, scrap iron, oil) to Japan.

February 5, 1938–
$5 sent to unfortunate war-stricken China.

December 2, 1938–
The speaker of the evening was Dr. Marion Bradshaw, who gave a most interesting talk, his subject being "The Cost of Peace." At the close of the lecture, Dr. Bradshaw very kindly stayed on and answered many questions on situations in Europe.

When German troops had marched into the demilitarized Rhineland in 1936, neither Britain nor France reacted. In March 1938, Hitler annexed Austria in the *Anschluss*. September 30, believing they had dissuaded Hitler from further aggression, Britain's Prime Minister Neville Chamberlain and France's Premier Edouard Daladier signed the toothless Munich Agreement. Hitler immediately annexed Czechoslovakia's Sudetenland.

In March 1939, Hitler occupied all of Czechoslovakia. Britain and France asked Russia to join in resisting a German invasion of Poland (which was obviously next), but Stalin, scornful of

the Allies' weak backbone, signed in August a nonaggression pact with Germany. On September 1, Hitler's troops attacked Poland with lightning speed (the *blitzkrieg*). Poland surrendered September 27; Germany and Russia divided the country between them.

September 10, 1939–
Guest speaker Mrs. James T. Volkman of Castine and Zurich, Switzerland, who is the president of the Federation of American Women's Clubs overseas. Mrs. Volkman gave a very interesting talk on American clubs overseas and women and conditions in Europe.

"The world is smaller and more intimate to us perhaps. And we are often conscious of the fact that American women form a chain around the world, linking with it the women of other countries in a band which perhaps women may some day know how to use."[5]

Russia invaded Finland on November 30, 1939. The Finns put up a valiant fight, but were overwhelmed and surrendered in March 1940.

March 2, 1940–
The tables were decorated as if at a Finland feast. There were colored candles, green firs, peasant dolls, and at each place was a

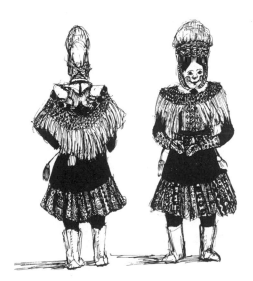

141

hand-painted placecard. The rolls were served from baskets and the after-dinner mints from wooden bowls. A very interesting and instructive program on Finland geography and history, the Finnish language and colonies in Maine, the Cause of the Russian and Finn War, the First Air Raid.

In April 1940, Hitler invaded Norway and Denmark; French and British troops landed there, but were repulsed. On May 10 German troops swarmed over Holland, Belgium, Luxembourg, and France. At Dunkirk one-third of a million Allied soldiers were evacuated across the English Channel. On June 10 Mussolini (who had invaded Albania in 1939) allied Italy with Germany, and on June 14, 1940, German troops entered Paris. Winston Churchill succeeded Chamberlain as prime minister; the Battle of Britain began and in September, steady bombing of London—the Blitz—commenced.

In the United States presidential election that fall, war or neutrality was a major issue. After Roosevelt's election to a third term, he made American sentiments clear in his "Four Freedoms" speech and advocated "Lend Lease" to Britain.

Stalin invaded Latvia, Lithuania, and Estonia in June 1940; early in 1941 Mussolini attacked Greece. On April 6 Hitler attacked Yugoslavia and Greece, and in June, in spite of the non-aggression pact, invaded Russia.

November 2, 1940–
Program: "The Appreciation of Our Democracy."

April 5, 1941–
Dr. E. Faye Wilson of the University of Maine. Subject: "The Struggle for Southeastern Europe." She gave a very clear picture of conditions in the warring countries. The members of the Castine Lions Club were guests and each member had the privilege of inviting a guest. A very interesting discussion followed the lecture.

May 3, 1941–
Miss Marguerite McQuaide, Field Worker for the American Red Cross, spoke on "The Red Cross in the Present Emergency."

November 8, 1941–
Speaker: County Chairman of Women's Division, Defense Council, who gave a very informative and practical talk upon the part that we as women must play in this business of National Defense.

6 "FAITH IN AMERICA"

December 6, 1941

Forty-six members were present for our December meeting. The Club collect was read by Mrs. Charles Devereux. Secretary's and Treasurer's Report. Letters of thanks were read from Opportunity Farm and for funds toward the school library. The following sums were voted for: Girl Scouts, Children's Christmas Fund, state Department of Health and Welfare, Health Bond, New England Home for Little Wanderers, Christmas baskets for needy families. It was stated that health seals had been sent to all members. Miss Anna Witherle spoke relative to the Red Cross, saying sweaters then finished would be sent before Christmas, the others as soon after Christmas as possible.

Mrs. Marguerite T. Blodgett [the daughter of founding member Geneva Hooper] then presented the speaker for the afternoon, Mrs. Ralph W. Emerson, Maine State Federation President, a former classmate of Mrs. Blodgett's at Simmons. Mrs. Emerson made a very gracious reply to her introduction, and then proceeded to enthrall her listeners with her very interesting address.

She told us that every Club woman has the opportunity to become an educated or well-informed person, quoting for us Aescrates' definition of education—a definition made in 400 B.C. but still workable. "Educated people are those who meet well the circumstances they meet every day."

She left us with this slogan for the 50th anniversary of Woman's Clubs in Maine: "Let us face the future with faith in our American way of life, and translate that faith into action."

The tea table was resplendent with red candles in silver candlesticks and a bouquet of red berries and pine.

ACKNOWLEDGMENTS

"A RISING VOTE OF THANKS"

The Castine Woman's Club for the privilege of reading and quoting from the minutes.

Margaret Bartlett, Roy Bowden, Philip and Margaret Booth, Florence Philbrook Crockett, Dorothy Devereux, Peg Hale, Margaret Hall, Kay Hooke, Louise Wheeler; and especially Helen Bartlett, Irene Bowden, Roger Danforth, and Donald Patterson for memories of Castine, the Woman's Club, charter members, and other folk.

The Castine Town Office, especially Rebecca Gray, for the chance to peruse old records, Pat Fowler, Kathy Eaton, and Liddy Fitz-Gerald of the Castine Library, Castine Historical Society President Gardiner Gregory, the Maine Maritime Academy Library, and the *Cemetery Book, Majabigwaduce* by Ellenore W. Doudiet, and the Castine *Patriot* for background material.

The General Federation of Women's Clubs (Mildred Ahlgren, Archivist), Maine State Archives, Oliver Wolcott Library in Litchfield, Connecticut, Wellesley College Alumnae Office, the Cooper-Hewitt Museum for its picture collection. Mary Donovan, Joanna Gillespie, Maggie Woolverton, and Wendy Murphy for information about the history of women's clubs.

Caroline Walker Young, my mother, for preserving the primary source material in her father's "old desk"; Virginia Weis Bourne, who knew what the minutes would mean to me.

146

Notes

CHAPTER 1

1. Mark Sullivan, *Our Times,* vol. 2 (New York, 1927), pp. 62, 92.

CHAPTER 2

1. Katharine Butler Hathaway, *The Little Locksmith* (New York, 1942), p. 77.
2. Time-Life Books, *This Fabulous Century, 1910–1920* (New York, 1969), p. 37.

CHAPTER 3

1. Sullivan, *Our Times,* p. 637.
2. Charlotte Perkins Gilman, *The Home* (New York, 1903), p. 84.
3. Charles A. and Mary R. Beard, *The Rise of American Civilization,* vol. 2 (New York, 1927), p. 401.
4. Ibid., p. 405.
5. Henry Fairlee, "Why I Love America," *New Republic* (July 4, 1983).
6. Mildred White Wells, *Unity in Diversity* (Washington, 1953), p. 169.
7. Wendy Murphy, "Furor Hortensis," *American Heritage* (August 9, 1978).
8. *General Federation of Women's Clubs Magazine* (September 1916).
9. *Brooklyn Daily Eagle* (November 13, 1902).
10. *General Federation of Women's Clubs News* (January–February 1924).

11. *Theatre Magazine* (1913), in Sullivan, *Our Times,* vol. 3, p. 611.
12. *Ladies' Home Journal* in Walter Lord, *The Good Years* (New York, 1960), p. 273.
13. Wells, *Unity in Diversity,* p. 227.
14. *General Federation of Women's Clubs Magazine* (April 1914).
15. Lord, *The Good Years,* p. 273.
16. Beard, *American Civilization,* vol. 2, p. 708.
17. Wells, *Unity in Diversity,* p. 217.
18. Richard Lingeman, *Small Town America* (New York, 1980), p. 273.

CHAPTER 4

1. William O'Neill, *Everyone Was Brave* (Chicago, 1969), p. 262.
2. Wells, *Unity in Diversity,* p. 196.
3. Ibid, p. 185.
4. O'Neill, *Everyone Was Brave,* p. 257.
5. Ibid., p. 262.
6. Ellen Glasgow, *The Woman Within* (New York, 1954), p. 296.
7. Hathaway, *The Little Locksmith,* p. 103.
8. Lord, *The Good Years,* p. 322.
9. Ernest R. May and Editors of *Life, Progressive Era* (New York, 1964), p. 32.
10. *General Federation of Women's Clubs News* (January–February 1924).
11. *Castine Patriot* (December 23, 1982) from *Lewiston Evening Journal* (November 10, 1923).

CHAPTER 5

1. Wells, *Unity in Diversity,* p. 190.
2. Beard, *American Civilization,* vol. 3, p. 742.
3. Joseph Lash, *Eleanor and Franklin* (New York, 1971), p. 388.
4. Beard, *American Civilization,* vol. 3, p. 787.
5. *General Federation of Women's Clubs Magazine* (October 1939).